CW00750096

Fairground Attraction

First published in the UK in 2003 by
Dewi Lewis Publishing
8 Broomfield Road
Heaton Moor
Stockport SK4 4ND
+44 (0)161 442 9450

www.dewilewispublishing.com

The right of John Comino-James to be identified
as author of this work has been asserted by him
in accordance with the Copyright, Designs
and Patents Act 1988

Copyright ©2003

For the photographs: John Comino-James
For the texts: John Comino-James and Dr. Vanessa Toulmin
For this edition: Dewi Lewis Publishing

ISBN: 1-899235-74-4

Design & artwork production: Dewi Lewis Publishing
Print: EBS, Verona

Fairground Attraction

photographs and essay by
John Comino-James

foreword by
Dr. Vanessa Toulmin
Director, National Fairground Archive

dewi lewis publishing

Foreword

This collection of photographs is remarkable not only for the beauty and clarity of the images but also for the world they portray – the hidden and secret lives of the travelling showpeople. As Henry Morley wrote, the history of travelling fairs is 'the unwritten portion of the story of the people, bound to the life of a nation by the ties of religion, trade and pleasure'. Yet though the physical aspects – the rides, the transport and the attractions – have often been photographed, the people themselves have largely been ignored. The National Fairground Archive holds 100,000 images of fairs in the United Kingdom and artists such as L.S. Lowry, Laura Knight and Stanley Spencer have painted the physical landscape – but the community itself remains largely unknown. A handful of outsiders have attempted to write about the showmen themselves but no one has sought to understand them from the viewpoint of the community itself, with the fair as the secondary attraction. This book attempts to remedy that – to understand the fairground and its history in the context of the people who return year after year to the annual fair.

I first met John at Nottingham Goose Fair in 1997 when I was co-organising the Form and Fantasy exhibition at Burnley Art Gallery with Fiona Venables. A selection of John's photographs of the Thame Fair showmen were shown as work-in-progress. I was immediately impressed that he had managed to get beyond the public face of the fair to capture the daily life and routine of the showpeople: the weddings, the christenings, their life in the winter quarters, and those social and family occasions that no outsider or 'flattie' would ever have been invited to. The bond of trust and affection between the showmen and John was evident, not only from the images but also from the pleasure and friendship shown to him in appreciation of his interest in their way of life.

John was always keen to see beyond first impressions, behind the gaudy painted machines and the hustle and bustle of the fair. He writes that he has developed a considerable respect for the showmen and feels privileged to have been allowed to photograph and see so much within the community. A peep behind the scenes, one could say, of a community on wheels. As well as presenting a photographic account of his relationship with the showmen, his essay is a wonderful historical account of the showmen's way of life, their business history and how the community is organised. This serves in its own right as a key text for future writers and researchers and reveals the story of how a friendship was built up between this strange flattie with his camera and the showmen who open at Thame.

And so this is not just a book of photographs commemorating and celebrating Thame and its fair – but also a tribute to the showmen and their families who have presented their amusements over two hundred years – revealing them to be an essential part of the social fabric of local and national history. In the words of Thomas Horne, the first General Secretary of the Showmen's Guild, life as lived in a van has pathos and power to move – as only true life stories can.

Dr Vanessa Toulmin
Research Director
National Fairground Archive

Street

Trailer and Yard

Celebration

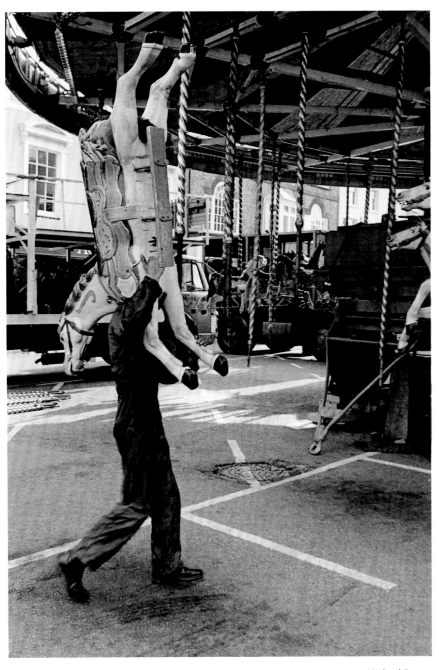

Michael Bacon
Thame Show Fair 1989

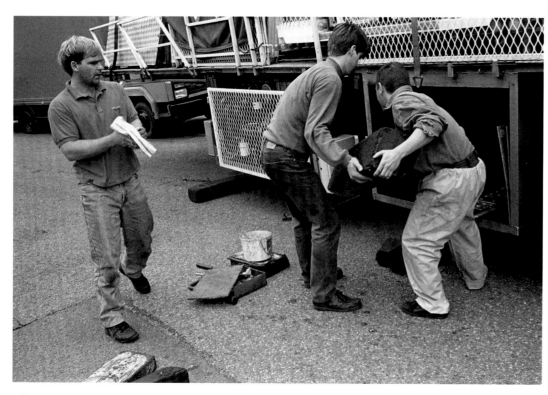

John Brixton's Meteorite
Thame Show Fair 1993

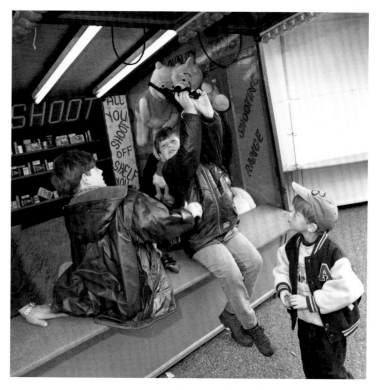

George and Aaron Rawlins and Stanley Farr
Thame Show Fair 1997

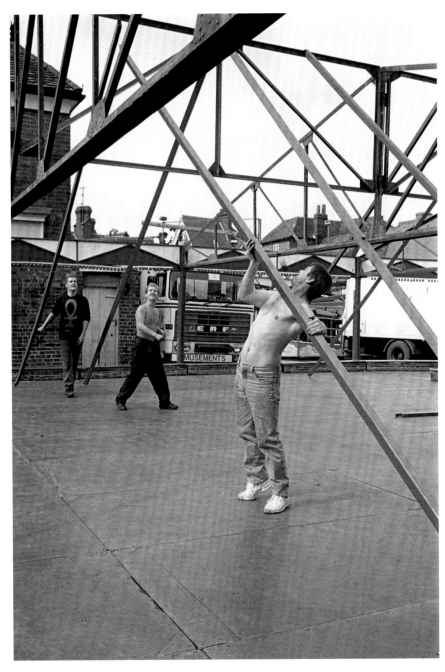

Webb's Dodgems
Thame Show Fair 1993

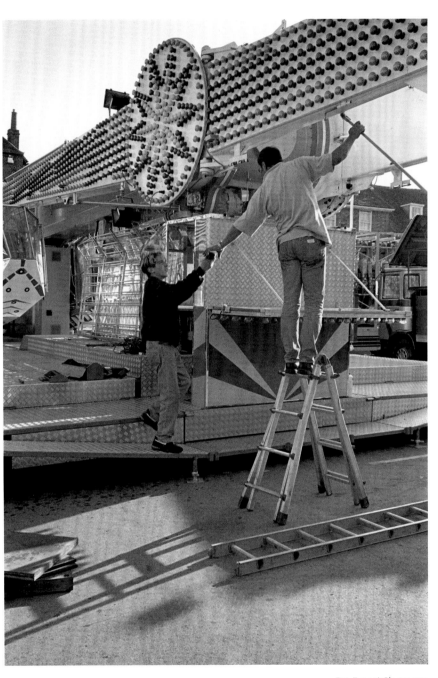

Pat Evans' Skymaster
Thame Show Fair 1995

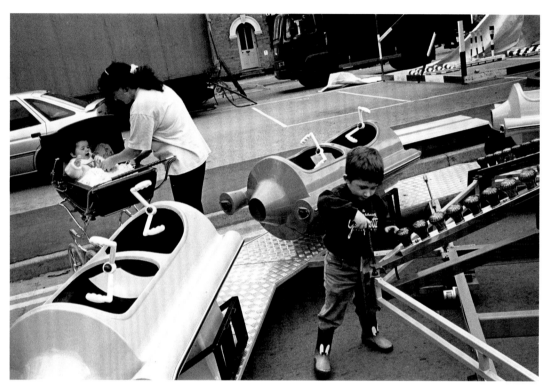

Jack Rose's Juvenile
Thame Show Fair 1995

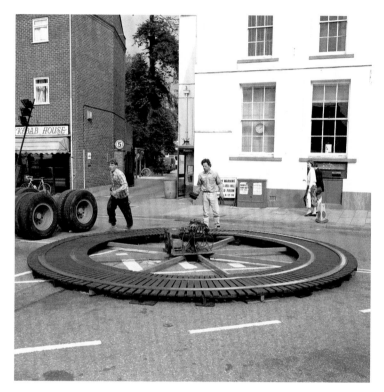

Bill Pettigrove's Toytown Express track
Thame Show Fair 1996

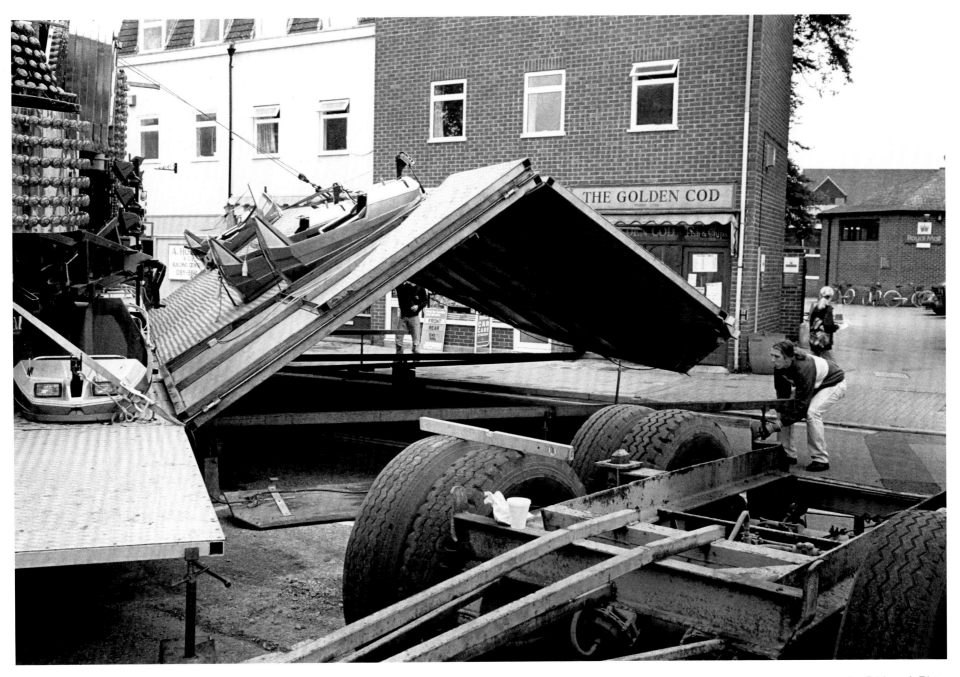

Len Pettigrove's Tristar
Thame Show Fair 1993

Arthur Rawlins and Asa Roberts
Thame Charter Fair 1995

Tony Crick
Thame Show Fair 1996

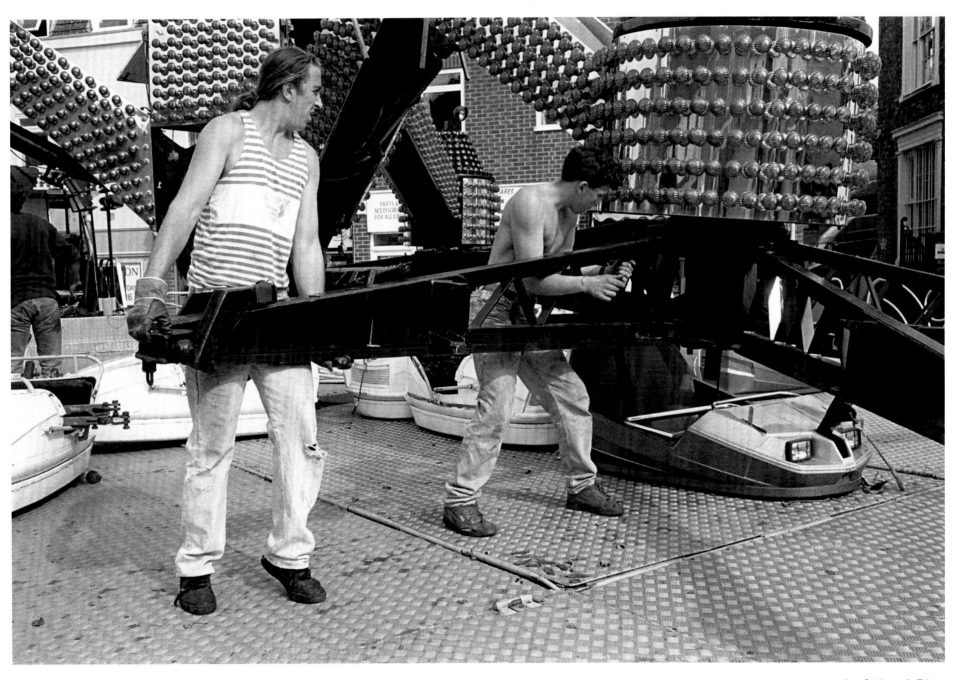

Len Pettigrove's Tristar
Thame Show Fair 1993

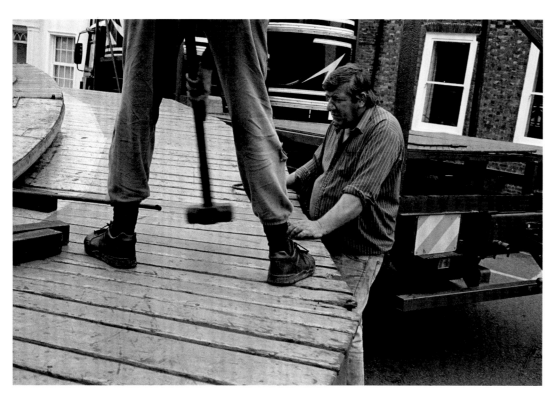

Donald Ive's Waltzer
Thame Show Fair 1993

Ray Pearson and John Woodward
Thame Show Fair 1996

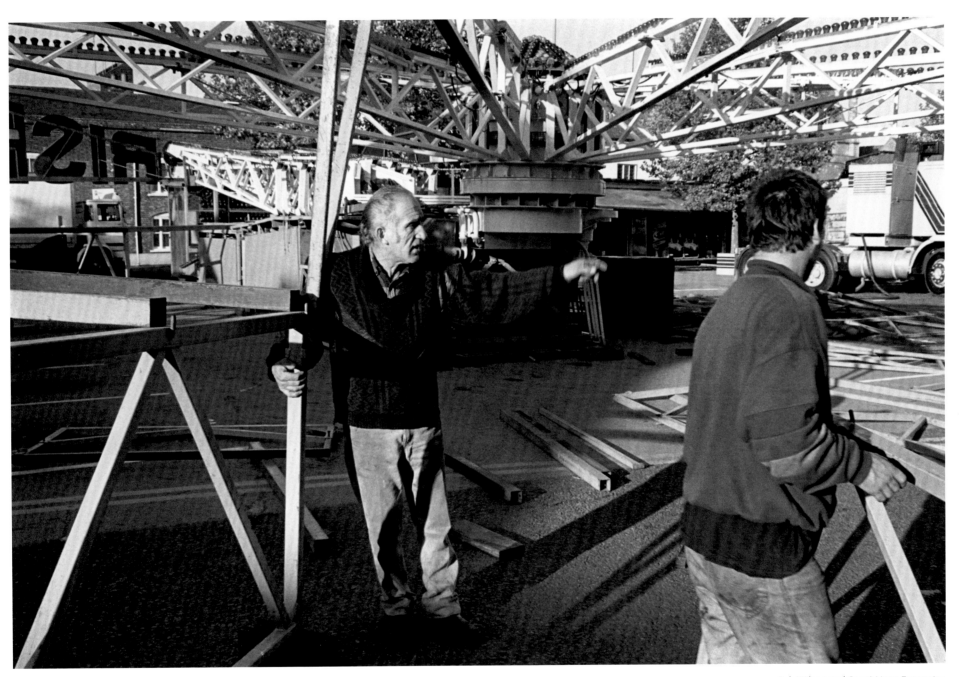

Bob Wilson and Sons' Huss Enterprise
Thame Show Fair 1995

Ann and Bill Pettigrove
Thame Show Fair 1998

Gary Penfold
Thame Show Fair 1997

Ayers Dodgems (on Webb's ground)
Thame Show Fair 1994

Buying Swag
Thame Show Fair 1995

Billy Butlin
Thame Charter Fair 1996

George Wilson's Space Train Track
Thame Show Fair 1998

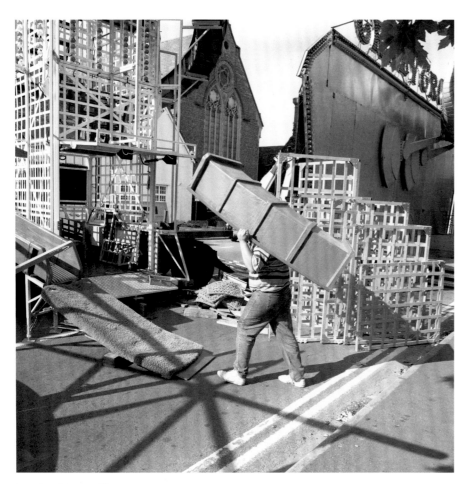

Jonathan Mason's Slip
Thame Show Fair 1996

Phillip Searle and his son Phillip
Thame Charter Fair 1997

Rosie Hebborn's Joint
Thame Show Fair 1998

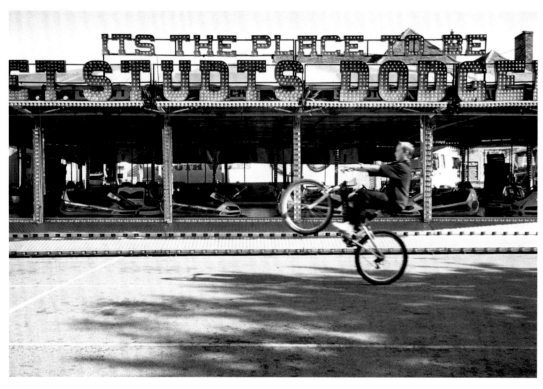

Studt's Dodgems
Thame Charter Fair 2000

Paul Webb
Thame Charter Fair 2000

Ronnie Bentley's Roller on Willie Wilson's ground
Thame Show Fair 1998

Jack Rose's Toy Set
Thame Show Fair 1996

Hoopla
Thame Show Fair 1998

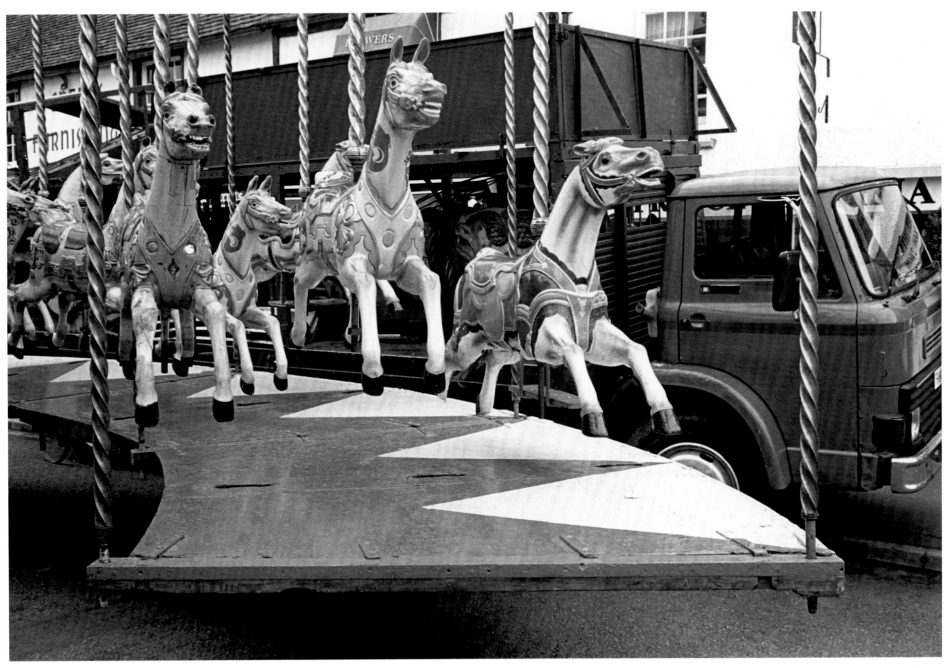

Mrs Sandra Pettigrove's Tidman Gallopers
Thame Charter Fair 1996

George Hebborn's Kiosk and Paul Owles' Hell's Gate
Thame Charter Fair 1995

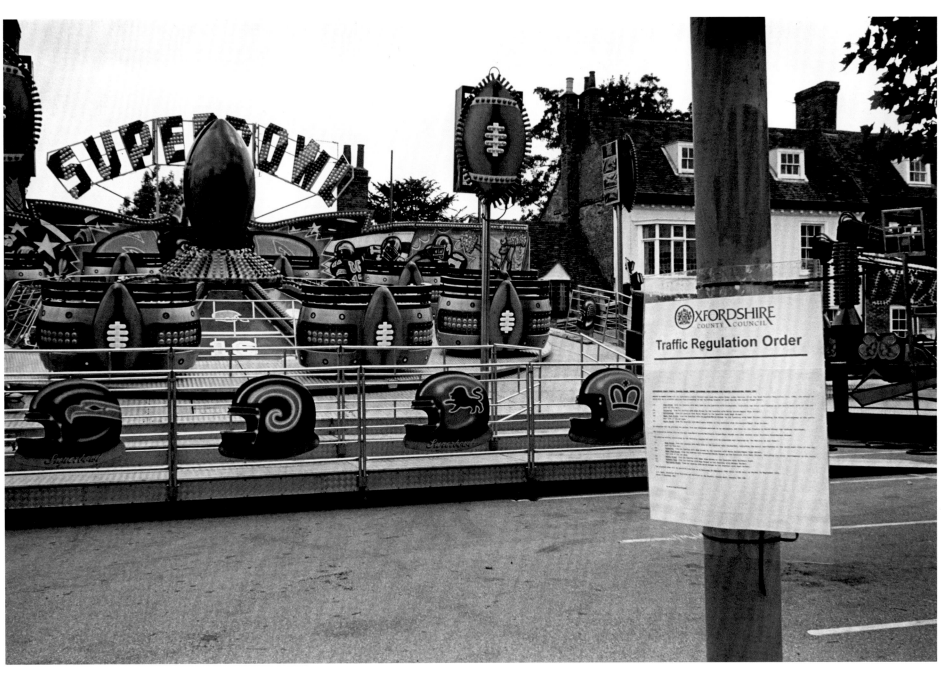

Traffic Regulation Order (Bob Wilson and Sons' Superbowl)
Thame Show Fair 1995

Tradition keeps us going most of the time, tradition and family keeps you going most of the time.

The family's the main stay. If it wasn't for the family it wouldn't carry on.

Sometimes you run it without earning a penny. If it wasn't family they wouldn't carry on would they, but you just carry on regardless. Its a way of life, a way of life all round, not just the money. I mean, I do like the way of life. I like the life. That's what the main attraction is really. With my friends, my family, all the time.

I've been with the same friends for the last forty years. Every week of my life, every day, or every month I'm with the same people now that I was childhood friends with and they're all married and have got children of their own now. I'm still friends with the same people. Not many people can say that. There are not many people who can go anywhere and know everybody in the room for a dance or a wedding.

And everyone knows me.

From a conversation with Tommy Wilson,
September 1997

Tradition keeps us going most of the time, tradition and family keeps you going most of the time.

David and Shelley Brixton
Thame Show Fair 1995

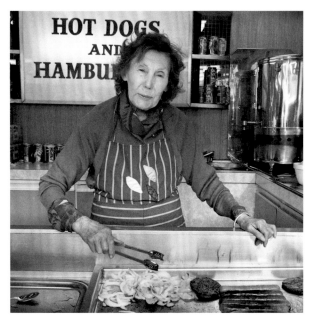

Lizzie Clasper
Thame Charter Fair 1996

Claudia and Charmaine Richards
Thame Show Fair 1996

Anita Irvin
Thame Charter Fair 1994

Sharon Rawlins
Thame Charter Fair 1994

Susanhah and Lydia Farr
Thame Show Fair 1993

Claire Smith
Thame Charter Fair 1995

Albert Richards
Thame Show Fair 1996

Shane Kayes
Thame Show Fair 1998

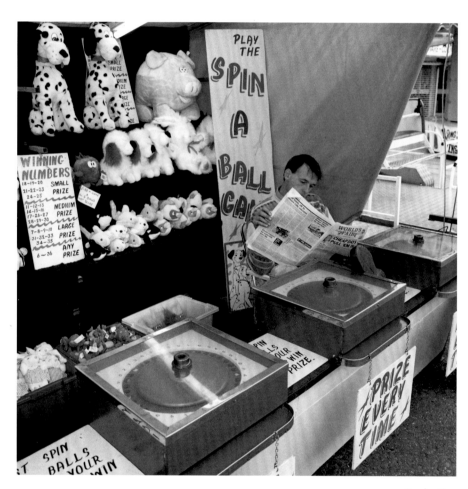

Stanley Farr
Thame Show Fair 1996

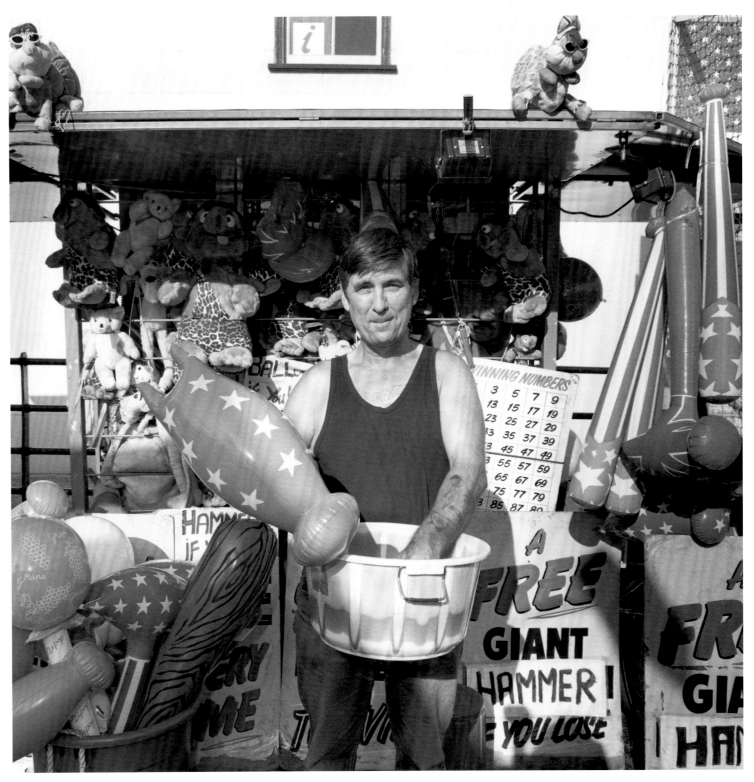

Ray Pearson
Thame Show Fair 1995

Gloria Brownsell
Thame Show Fair 1998

Sharon Wilson
Thame Show Fair 1998

Ann Pettigrove and Suzanne Bibby
Thame Show Fair 1998

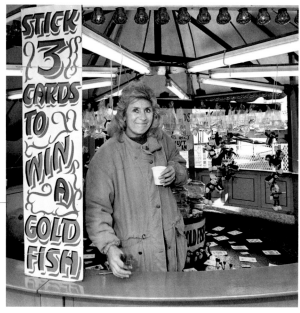

Margaret Richards
Thame Show Fair 1994

Gloria Hebborn
Thame Charter Fair 1997

Linda Penfold
Thame Show Fair 1996

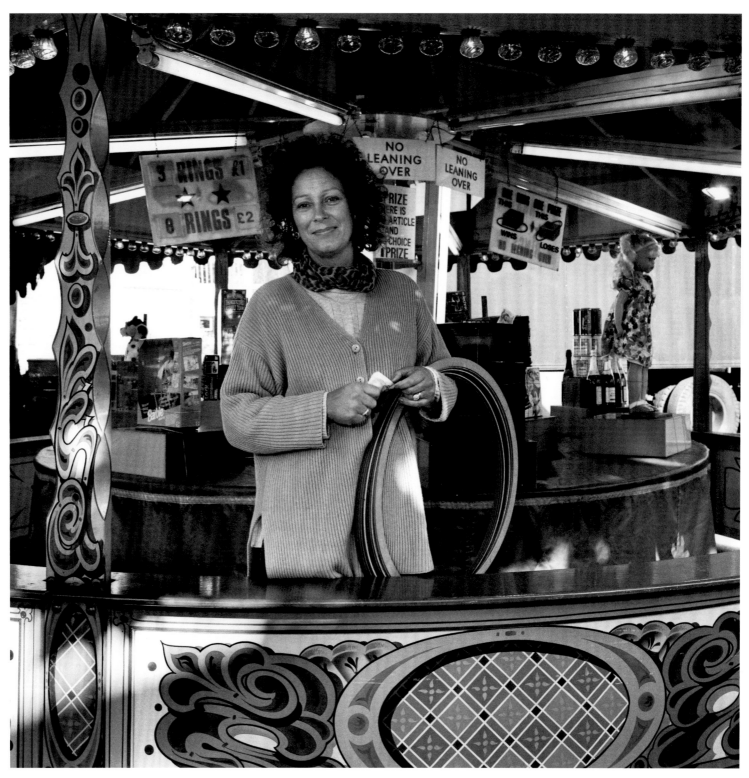

Rhoda Searle
Thame Show Fair 1996

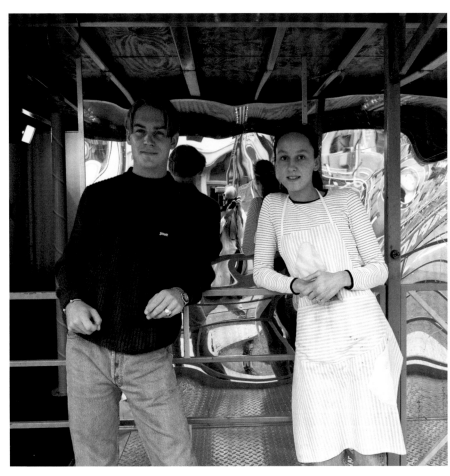

John Penfold and Carlie Wilson
Thame Show Fair 1997

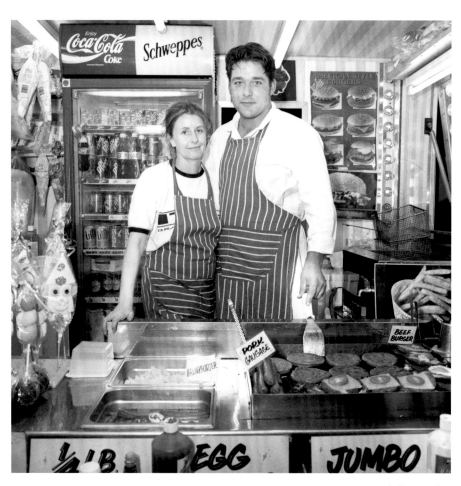

Lisa and Elliot Burden
Thame Show Fair 1998

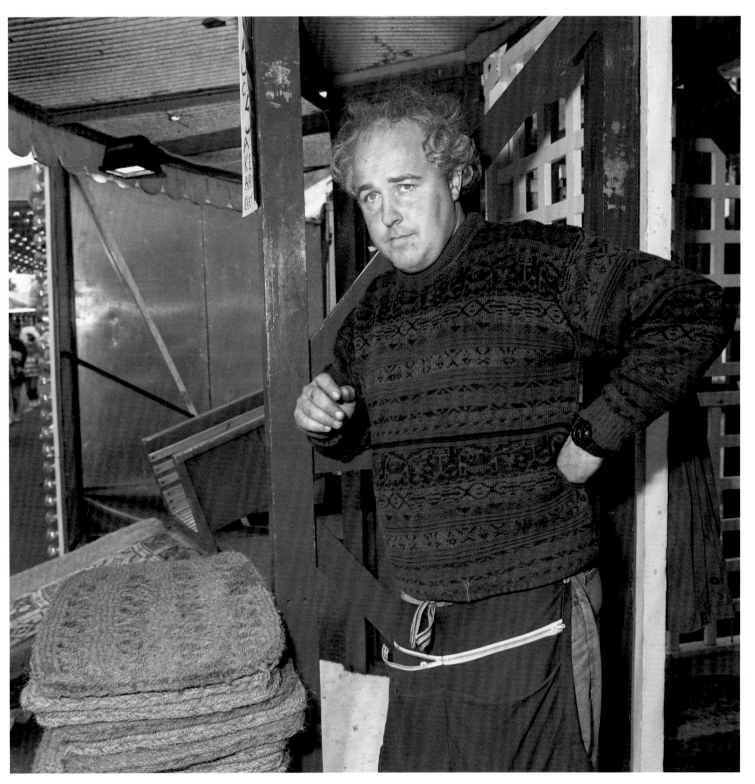

Dolphe Crick
Thame Show Fair 1993

John Penfold
Thame Show Fair 1995

Harry Farr
Thame Show Fair 1992

John Rawlins
Thame Charter Fair 1997

Tommy Rose and Jason Hebborn
Thame Show Fair 1995

Sean Bibby, Michael Bacon and Bradley Bibby
Thame Charter Fair 1994

George Rawlins
Thame Show Fair 1997

John Buckland
Thame Charter Fair 1995

Gary and Danielle Walford
Thame Show Fair 1989

Raymond, Candice and Rachael Pearson
Thame Show Fair 1998

The family's the main stay, if it wasn't for the family it wouldn't carry on.

John, Alison and Alfie Reed
Thame Show Fair 1998

Lena Mason nee Rose and her daughter Bobby-Joe
Thame Show Fair 1995

Jackie Rose nee Biddle
Thame Show Fair 1995

Four generations of one family at Thame Show Fair, September 1995.

Lena Biddle nee Taylor
Thame Show Fair 1995

Shane Kayes, Frankie Howard and Frank Howard
Thame Show Fair 1998

Amy Charlotte Gregory, Tom Wilson, Chantelle Wilson and George Wilson
Thame Show Fair 1998

Travelling children, they want to be Showmen! This is their way, it's deep, very very deep, generations deep.

Simone Smith and John Wilson
Thame Show Fair 1998

It doesn't make any difference for girls. I knew a girl a long time ago called Dani and I just liked the name.

Most travellers do name the boys after their dads.

I don't necessarily agree with calling them after their dads because it's the surname that carries the name on as far as I'm concerned, not the first name.

I can remember when I was at home – my dad's Jim, my brother's Jim. You'd call "Jim" and they'd both come running. So I just like different names.

I didn't like the name Edward. I like modern names and Edward's an old fashioned name and I don't like old fashioned names. I didn't want it to be Big Edward, Little Edward and Baby Edward which it would have been as we're usually together with Edward's dad.

At the crucial moment I did ask Edward if he wanted him to be called Edward but he said, "We'll call him Asa Edward."

I raised a few eyebrows by not calling him Edward.

From a conversation with Debbie Roberts, September 1997

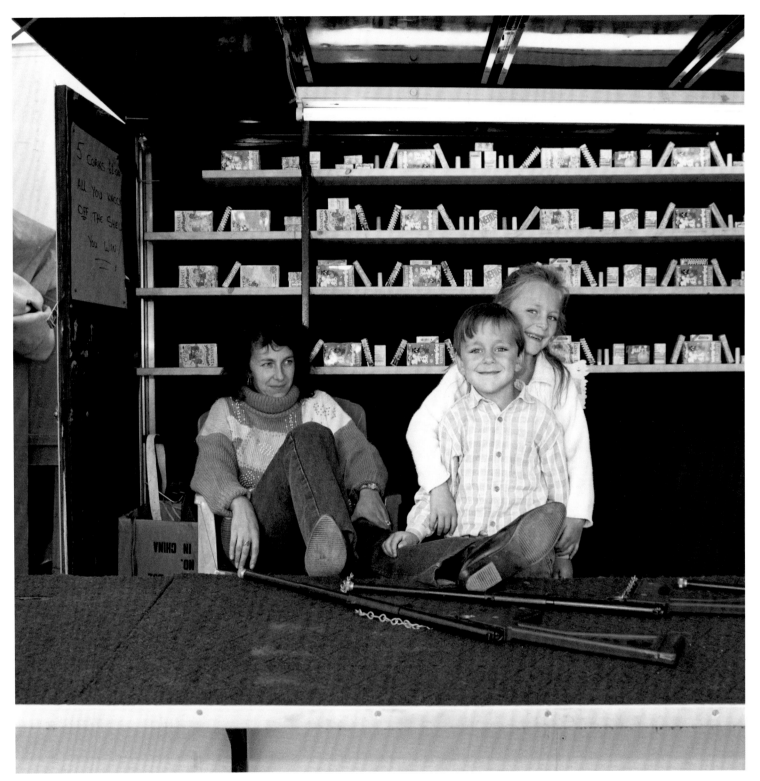

Debbie, Asa and Dani Roberts
Thame Show Fair 1995

Ray Bushaway, Jimmy Hatwell and Alfie Gregory
Thame Show Fair 1997

Ashley Bacon and Sean Bibby
Thame Show Fair 1998

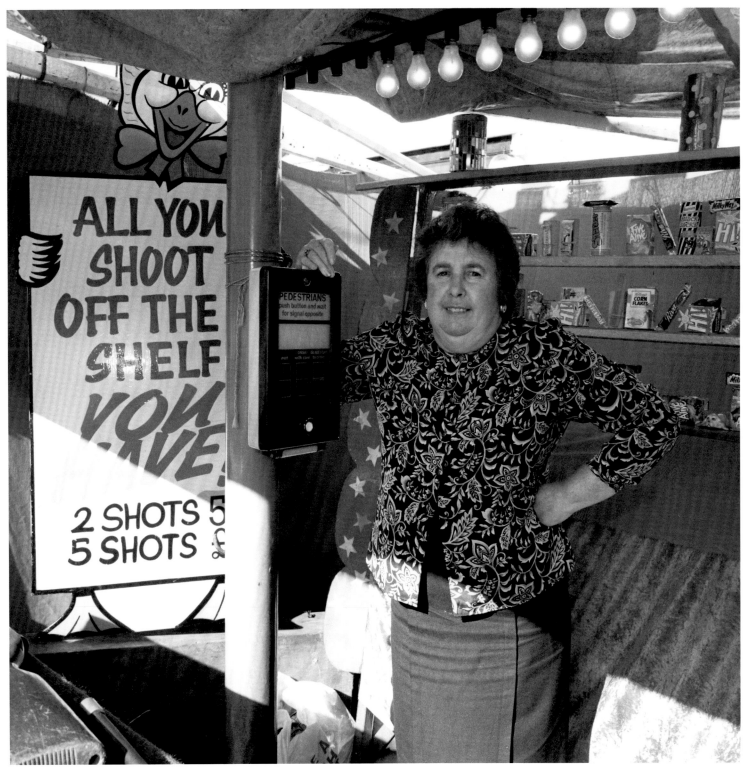

Rosie Hebborn
Thame Show Fair 1998

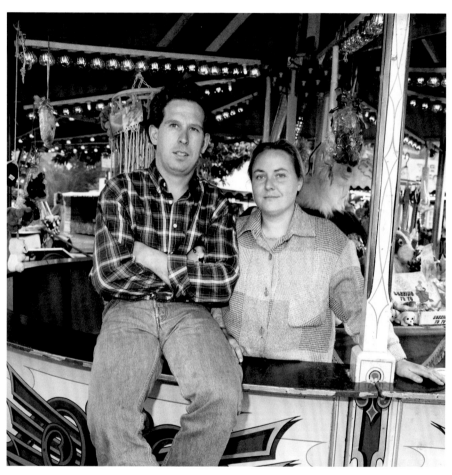

Bill and Louise Pettigrove
Thame Charter Fair 1995

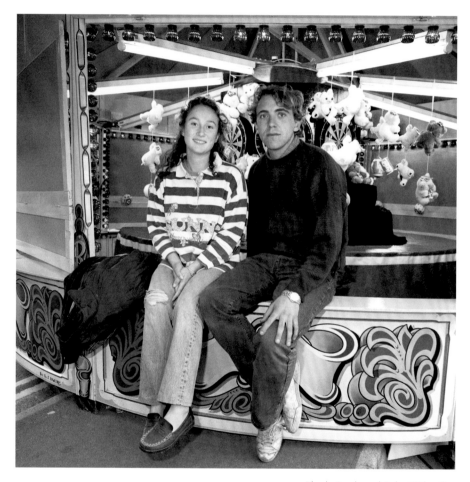

Rhoda Searle and Robert Wheatley
Thame Show Fair 1996

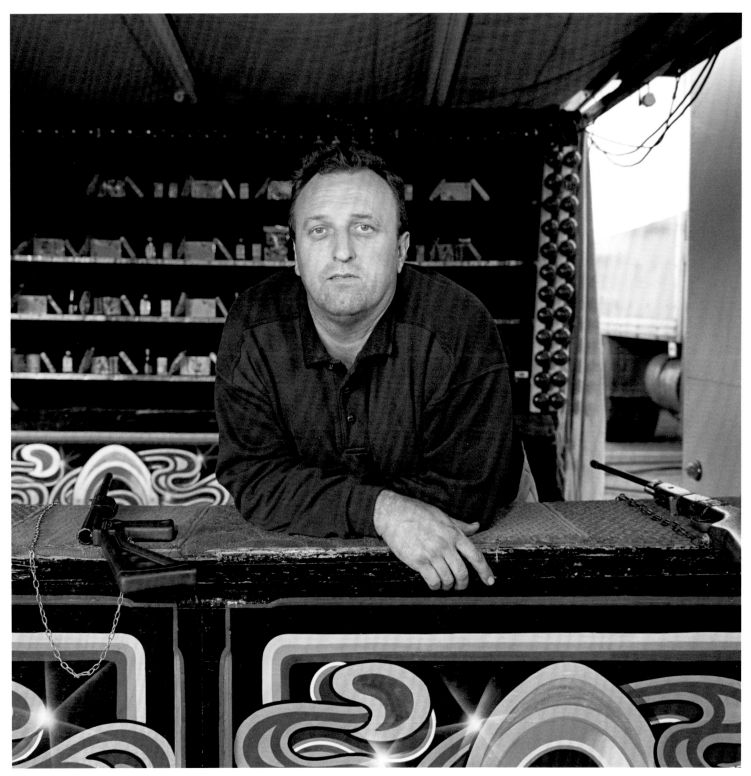

Fred Bibby
Thame Charter Fair 1994

I'm talking about Mr Millard's shop, he was the outfitter. Uncle Rinkie used always to order his clothes there every year. He knew Mr Millard personally you know. I mean if you were walking down the street he'd call, "Hello Mr Shaw, how are you?" first thing on his mind. He always ordered his pure wool pants and long sleeved vests there. Every year he'd have an order for three sets of each because he couldn't get them any- where else and also the little cardigans because he was quite petite. And it was usually a Crombie overcoat or a suit he had made there every year. Mr Millard was more like a friend of the family.

In the Buttermarket there used to be, I'm talking about forty-five years ago, there used to be a grocery store and the man used to come down to where the caravans were. The caravans were in the street behind our stalls and he used to come down on his bicycle with the big milk churn in the top and he'd sell us milk, you know with the measure. He'd take the lid off and ask did you want a pint or two pints like that. Right round by the town hall, that was packed with caravans and lorries. Right in front of the sweetshop. The steps were on the pavement. People in the houses didn't like the caravans being in the street because if it was cold you had to light a fire and of course the smoke had to go somewhere and it went in their houses and they said it would be best if all the caravans were taken out of the street.

Our caravan was up Nelson Street. Do you know the dentist on the corner? Now our caravan was there and you'd go across the road into the dentist. I had the toothache one year. I had it right till we got to Thame and at Thame it just went because the dentist was there behind our caravan. My auntie kept saying "Are you going to have that tooth out?" and I said, "No." She said, "The dentist is only just across the road," and I said, "I haven't got the tooth ache now".

This was just when auntie was alive, uncle was gone by then.

From a conversation with Betty Dunklin, June 1995

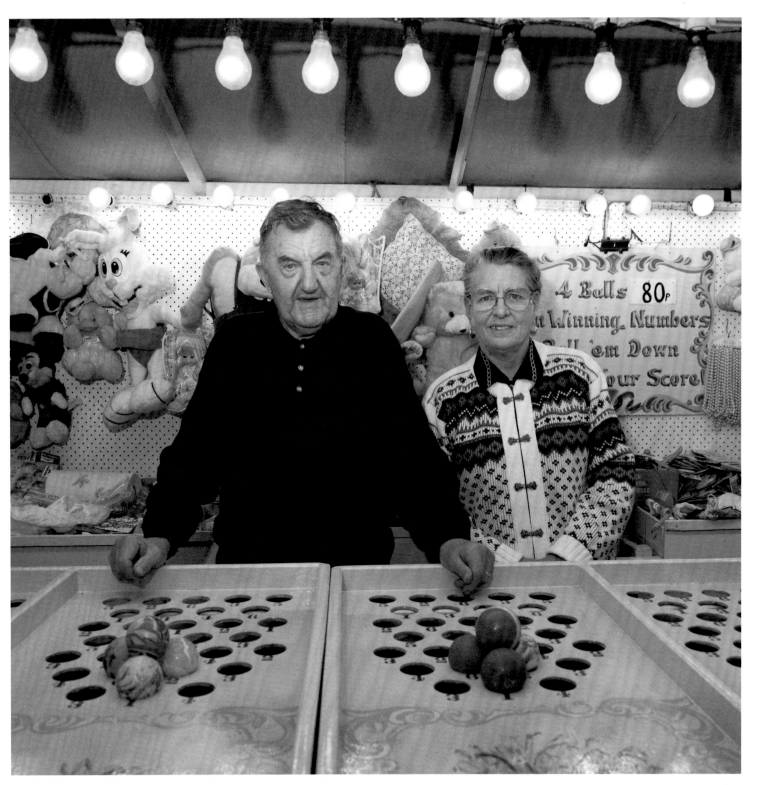

Dennis and Betty Dunklin
Thame Show Fair 1994

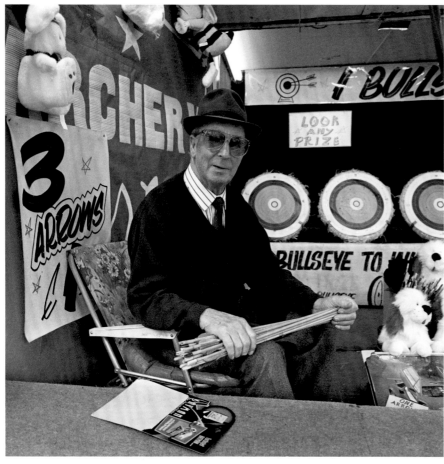

George Crick
Thame Show Fair 1994

Edward Roberts
Thame Show Fair 1998

We are business people, it's just that our business requires us to travel from place to place.

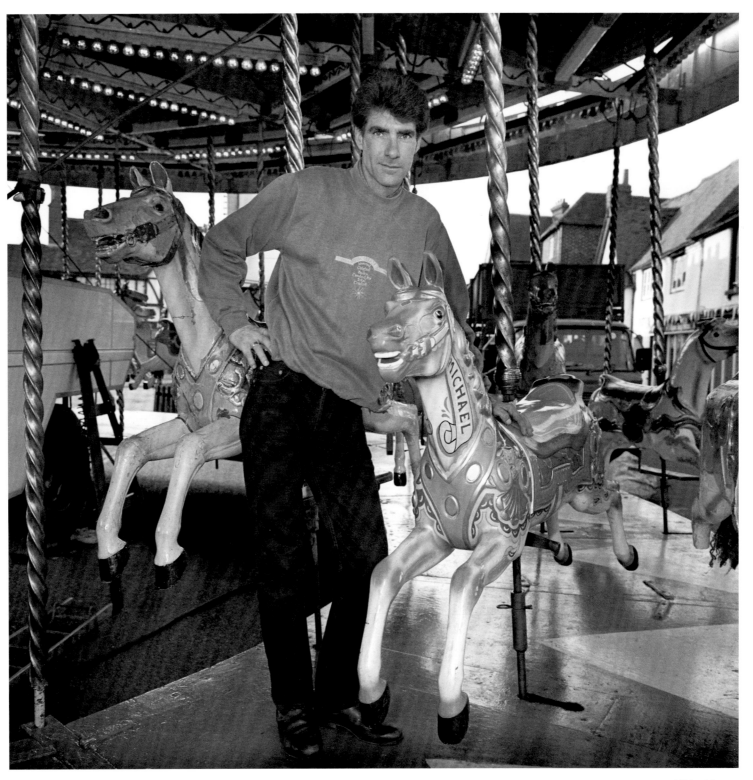

Michael Bacon
Thame Charter Fair 1994

I was born at Baldwins Farm, that's on the road that goes out of Thame, because during the war mum and dad stayed there because of the blitz. They came out from Hackney and Deptford and mum and dad just stayed out that way during the war. It was quieter, more subdued for kids and everything. I was born there and I've never missed a year since I was born. Never missed one year, I've been there every year since 1946.

Daisy my sister was born at Brazell's Garage, which is now that Shell garage as you go out of town on the left. At the back of the cattle market, where the houses are built now, there was a grass verge and we spent about five winters there on the grass verge. I've got a lot of ties to the place really.

Just past the Police Station on the right there was a church. I don't believe it stands any more and it was corrugated steel, corrugated metal. It wasn't a church of brick, I don't know why it was a corrugated church. We were all christened in there. My brother was christened in there. We were all christened in there.

Grandfather died before I was born. He died behind Brazell's garage and when they buried him they brought the coffin and the funeral through Thame and they had a minute's silence where now we put the juvenile and the hoopla. That was the position the spinner always used to stand, and they stopped there for one minute's silence before they went on to Oxford to bury him.

From a conversation with Tommy Wilson, September 1997

Tommy Wilson
Thame Show Fair 1994

George Hebborn
Thame Charter Fair 1995

Victor Farr
Thame Charter Fair 1994

George Wilson
Thame Show Fair 1995

We look forward to going to the streets – Abingdon, St. Giles, Thame Show. You see some of your friends that you didn't see since last year whether it's showmen or general public.

I've been going to Thame since I was seven or eight years old with my grandmother, I've done Thame for fifty years or more. You see what used to happen, when I was about seven or eight years old, my father used to drop me off to help my grandmother round all the back-end fairs because we didn't have the same positions. In those days I suppose that was half of our education, we learned to count, we learned to give change with money, and we only went to school in winter. If my father was at a place for a fortnight then he would put us in school but if we were at fairs for one or two days then we didn't bother.

My grandmother always said stock was as good as money. Just after the war when they started travelling again she went to London on the train to a warehouse that was advertised and she bought policemen's helmets, PC 49 – if you remember PC 49. She bought a warehouse full of policemen's helmets and monkeys. I was a child in those days and when I got married she still had a few of the odd hats and monkeys left.

My family's made rides since just after the war. My father made them when we lived at Watlington. He only made them for himself and then, as I got older, me and my brother started making them but that was only for ourselves, not for selling. And then my sons have taken over and built up the manufacturing business.

A friend of father's came to him one night in the winter and he said, "Bob, I want you to build me a one horse roundabout." My sons still don't believe me from that day to this – but well they do because all my family knew about it you know. He wanted it for the garden and dad built it for him. It was a pole, just one swift and rod, and just one horse on it, just for his children.

One of the main things that's changed is everything's moving faster. I mean my grandfather used to come from Hampstead Heath with horses down to these Oxfordshire villages and then he came down with steam and now we're just pressing a button on diesel lorries and still we haven't got time. Where's the time going? But they did it walking with horses and then travelling with steam. They still caught the same fairs and I think they lived a quieter life really, there wasn't the rat-race you know.

My father, he was always the sort of man who'd rather live a quieter life doing all little villages and try and make an honest living without the rushing and tearing about. Dad was more of a one to take less and live a quieter life; he wasn't lazy, don't get me wrong, but he thought, "What's the point of it?"

And you know I've been to Thame all those years and I never once did go to the pictures. You wouldn't believe it, would you? Never did. I was always the first stall built up for my grandmother, first one built up and finished and never went to the pictures.

From a conversation with Joe Rose, December 1997

Joe Rose
Thame Show Fair 1993

This was in 1982. My dad was in the car going down to York to an army sale. In the family car was a friend of my dad's and he was looking at World's Fair and he spotted this Roundup ride for sale at York at Flamingoland and he said to my dad, "There's a ride for sale in the park we've just gone past."

On the way back we looked in and this lady showed us the ride and she said two showmen had been down and seen it and hadn't come back and that was six weeks ago. Three weeks went past and the people who owned the park rung us and they asked if we'd come up and look at the ride again.

We went and had a look round it and ended up buying the Roundup. It was a modern ride then, it had just come out of the factory eighteen months, two years old. Then we rung up Keith Emmett who was good friends with my dad at the time and young Keith came down with us to pick the ride up. We went in the old Atkinson Borderer – me, my dad, and young Keith. Young Keith's dad was manufacturing rides and revamping them and when he saw the ride young Keith said, "Do you know what you've bought here" and we said, "Yes, a Roundup". And he says, "No," he says "Do you know what type of ride you've bought?" and we said "No". He said, "This is the Rolls Royce of Roundups, it's the Sam Ward. You can't get any better than this make of ride. This is a top notch ride."

And we drove back down the M1 back to Cosgrove and into Keith Emmett's place and we never even opened the ride and Keith was bidding us for it at eleven o'clock at night trying to buy the ride off my dad. And my dad looks at me and he says, "What do you want to do son, do you want to keep the ride and try it for a summer or should we take a profit now and let it go and make a few quid out of it without even touching it?" and I said, "Let's try it for a summer," and it was a good move.

We did it all up in that winter of '82 and I started knocking about with Sam as well and when we got married in '89 I had the Roundup, took it on.

That was it. That's how we came to get it. And the work to look after it ever since as you've seen!

From a conversation with John Brixton, July 1997

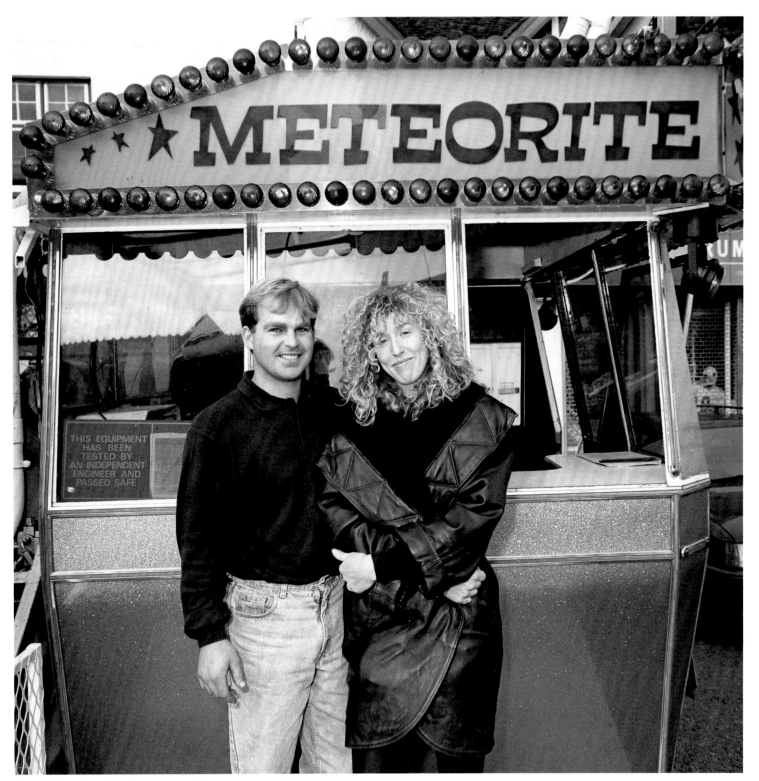

John and Samantha Brixton
Thame Show Fair 1993

I wanted a juvenile – a kiddies' ride – so I went and saw Jack and Joey Rose to have a cup and saucer ride made, but a cup and saucer ride with a difference. I'd seen one up at Hull fair with fruit and pears and bananas and pineapples and things like that rather than cups and saucers.

They said they'd have to look into getting the moulds but said they were thinking about making another juvenile with buses on, double decker buses. They said their cousin Marshall, Bobby's son, had got a mould for buses. They'd thought about making four buses on arms going round on wheels. I said that sounds good, and I'd be interested. So anyway I went back and saw them again and said, yes, I'd have one and they carried on. I got the money together and in the September they delivered it to Wallingford Fair and I opened it at Wallingford. And I'm very pleased that I had it.

From Wallingford I went on to Abingdon and from there to Thame October fair where you took this picture. That would have been in 1994.

I see you've got other pictures later on after it was painted. Another one of my cousins, Stanley Farr, young Stanley, he did the decorating on the rounding boards. I wanted something with my name on there. For the buses themselves I sent off to the various bus companies who I wanted the buses to represent, for instance London Transport and Blackpool and Tappins Coaches to represent Oxford and what have you and that's how I got the logos to go on the buses.

If you go back in time, my family, the Bucklands, were always renowned for their coconut sheets and I should imagine they've been going ever since the Show has been in the street, its over a hundred odd years, and to the Charter Fair as well.

They all had big families in the old days. My grand-father who was Owen Buckland had nine brothers and sisters, and he himself had five children. One of my grandfather's sisters was Bella and she married Bill Spurrett who was Tony's grandfather. And another of his sisters, Clara, married old Joe Rose and that was Joe and Bobby Rose's grandparents, which is how I come to be related to Joey and Jack who made the juvenile. One of my father's sisters, Doris, she married Victor Farr – I see you've got his picture in – and another sister Leanda, well Nunny they called her, married Siddy Biddle and they had three daughters, Violet who married Johnnie Rawlins, and Sarah who married Stanley Farr whose son Stanley I told you painted the roundings on the juvenile, and Rosie who married Harry Hebborn who's got the Waltzer where we had the opening at Thame this year. And of course it doesn't end there, it just goes on and on!

From a conversation with Nathan Buckland, November 2002

Nathan Buckland
Thame Charter Fair 1994

Well we started from the yard for Hampstead Heath. That was for Easter.

From there we went to Abingdon with John Irvin which is about sixty miles. We did three trips there starting about seven in the morning and it took all day till ten o'clock at night to get there. That's before Karen started driving the little lorry. From Abingdon we moved to High Wycombe. We stayed there one more week and I got Karen used to driving the lorry. We had a nice big open field, up and down, up and down. She had a short journey of three miles up the road, her first trip for the May Day on the Rye. Then its Beaconsfield. After Beaconsfield? Elton Regis near Dunstable. By now Karen's driving the lorry so it's half the time. We get there and finish by six instead of ten now. That's for one week then back to Hampstead Heath again, that's the Whitsun bank holiday. A short trip over to Epsom for the Derby, two weekends. From the Derby to Caterham. Then back in the yard for a couple of weeks, then Marlow. Back in the yard again for a couple of days, then Sittingbourne in Kent. Then we go from Sittingbourne to Rayleigh in Essex.

From Rayleigh back to the yard for a couple of days and then we were off to Devon. It took us two days to get down there. That's three trips and we did about a thousand miles moving our stuff in two days. We stayed there for a nice comfortable six weeks, no building up, no pulling down, not a lot of money involved but it was nice relaxing time.

From there, Oxford St Giles.

Abingdon just for one week. Then its been hectic since as you know, one place to the next to the next: Thame, Wallingford, Nottingham. Then we're on to Abingdon Monday and Tuesday. Wednesday back to Thame and then from Thame we'll go back to Abingdon again for the little runaway fair. From Abingdon we will go to Banbury.

By now I'm really tired. We finish Banbury on the Friday and we open on the Saturday at Buckingham, from Buckingham we got about five days off to relax and then we go for our last stop which is Milton Keynes and that's for three weeks for the bonfire.

Then back in the yard about the middle of November. Two lorries, the jeep, three trailers – not living trailers – you know trucks, and one living trailer. We've got a lot when it's all together. I've got to remember where I've left half of it. We've got it all split up at the moment. I've got to count them as we go away, make sure I haven't left any. Like the kids!

From a conversation with Arthur Rawlins, October 1997

Arthur and Karen Rawlins, and their sons Karl, Arthur and Tyler
Thame Charter Fair 1995

Well I'm seventy-two and I've been coming here all my life.

My dad, he was here before me. I had a brother born at Haddenham on the green, I had a brother born at Milton, and I had a sister born at Abingdon. And I had a brother die here. We were down here on the site by the Birdcage and we were open. The Show was on, it was Show Day.

I had a sister Ethel, Doreen's mother, and she got married at Witney Feast and her first journey in her married life was from Witney Feast to Thame Show. I was only a little boy, I can barely remember it. When they got here he put up his things that he had to operate and they went in the pub that night and had a booze up!

We've been round here all my life, Warborough, Brill on the hill, Long Crendon, Haddenham, Stadhampton on the green, Shabbington.

Years ago we used to go into Stone asylum and take a fair in there and then we used to go from there – this is with horses pulling the trucks – we used to go from there to Hampstead Heath for our August holiday. We used to have a big set of swing boats and a little set of swing boats. We used to have a ring hoopla, and we used to have a pulling board – which you don't know what that is – but we used to have a pulling board and a coconut sheet. And the roundabout that we used to have is the roundabout that John's got now.

We used to do a lot of little Feasts round here on our own. You could do them and come away with nothing, that's how it used to be in those days you couldn't get hold of anything, barely keep the family going. There were ten children and my mum and dad. Mrs Crick is my other sister. With such a big family you had to have such a lot of stuff up to keep the table going. That's what it used to be.

This fair, this used to be a horse fair. All over there at the back by the Swan used to be roped off. Oh it used to be lovely, they used to run the horses from there to there and run them back and somebody'd make a bid. I used to like this better than the Show, I used to love it. We never had what there is now, this big equipment. You'd have a load of vans all the way along the back. Lovely there it was, very nice. I do remember that. It was a long time ago.

Well, my dad never retired. I can't see me retiring out of it. All as I can see me doing is I won't be able to carry on with it.

From a conversation with George Rawlins, October 1997

A PRIZE
EVERY
TIME

George Rawlins
Thame Charter Fair 1994

We open all over the country really. We do Easter either in the Midlands or in Birmingham or London then we go to Kirkcaldy in Scotland. We've just come back from Neath. We do Cardiff in August, and Gloucester. We do a lot of work in London. We do Leicester Square at Christmas time. We have a carousel this year in Hyde Park for three months, the first time they've done that. Bridgewater, Barnstaple, West, South, North, all over the country really, and we can be in three or four locations at one time.

We have offices in Birmingham and London which co-ordinate these things with us. We have our own family that can go to different shows and we have other people who can go to different shows.

I think our industry hasn't sold what we do and how we do it. There's a lack of understanding of how complex and how integrated the actual business is. A lot of people still expect the showman to have an earring and a red scarf and a pair of brown boots and be quite illiterate. This is bad PR from our own side I think.

We are lessees of about fifty fairs a year. Major ones on size, I suppose you'd be talking about Witney, Stratford-upon-Avon, Banbury, Ealing Common, Leicester Square and several others. We finish in mid-January and we start again in mid February. We stop about a month a year.

We concentrate on major rides, that's our forte, that's the thing we do.

People are always looking for more, for faster – that's the way of the world at the moment unfortunately and that applies to fairground rides.

And I suppose one of the biggest dangers to the industry at the moment is that you have an over capitalisation on rides. You have to invest at a higher rate and it doesn't always quite stack up as it should because you're investing more money than you can see a return on in the short term. People are becoming more fickle in what they like so the novelty factor lasts a shorter time than it did five years ago.

Fairgrounds rely upon spare cash in people's pockets and people don't have spare cash. The majority of people's money is accounted for today and that comes I think from having a very low inflation rate so salaries aren't going up, they budget what they can afford to buy – i.e. house, car or what have you – and it leaves them very little else to spend. That is I think the underlying problem at the moment. We have this situation where it all looks very good on paper. We appear to have a good economic situation but I don't think we particularly do. People just do not have the cash to spend. It's not that they don't want to spend, numbers aren't dropping, it's just that cash flow's dropping.

I hope we're selling a slightly different product to when you and I were younger. If we're not we've got it very very wrong because that's what it's all about: to be different. The lifeblood of the fairground is that it has to change because there's nowhere else, no other entertainment where you can take the family and everyone is comfortable in the atmosphere. For instance if you have grandchildren and children you can take them all, there's something for everyone. And we still have a free situation. You can walk round and be entertained without spending a penny. That has stopped the same, but the technology has improved tremendously and that needs to be the way.

We need to have the improvement of the technology, the faster, the higher, the more frightening, the more pleasing ambience. I've seen tremendous changes inside the industry particularly with the approach on safety, and on presentation, and a colossal investment.

In many cases we get viewed as pure itinerants and we don't have sufficient backing from central government as most businesses have and I think we need this. Without that I can see major problems for funfairs in general.

Travelling is the spice of life, its what it's all about. The only way I can see my stopping travelling is if it ceases to become viable.

You have many, many travelling families third fourth fifth sixth generations. I can't think of another industry that can actually say that, it must be unique. Travelling children, they want to be showmen! This is their way, they want to do it. It's very very deep, very deep, generations deep and that will never change as a whole, and who wants to see it change.

From a conversation with Willie Wilson, September 1998

In 2001, Willie Wilson, Managing Director of Bob Wilson Funfairs, was awarded the MBE for services to charity, the first showman ever to be bestowed with the honour.

Willie Wilson
Thame Show Fair 1996

That board that says LIVE AMMUNITION, that's been on every shooter I've had since 1948 or whenever it was. It's got a bit tatty and we've had it repainted one or two times but it's the same one really. Dad always used to say, "Hang on to something of the old." More or less superstition for luck. It's like something borrowed when you get married isn't it.

Twenty, twenty-five years ago shooting galleries sort of died out, the ammunition was getting too expensive and the insurance was going up. There were new restrictions coming out, you had to have bullet-proof sides and tops and things like that where we used to have canvas roofs in the old days. They stopped making disintegrating bullets and we had to adapt to take ordinary .22 ammunition. I got some advice from Eley Cartridges about that, I got a blueprint with all the angles of the plates all worked out so that the bullets are deflected downwards into sand.

The old pump action Winchester is the traditional gun for a shooting gallery. I'm still using ones my grandfather had, oh, many years ago. They're the 1890 model, the one with the hexagonal barrel. They stopped producing the round-barrelled ones just before the war, but you can still get the Winchester lever action, the model 94, and they're a popular gun. A regulation came in that all the guns had to be chained. It limits the arc of fire so you can't take the gun and shoot it out into the fair, which is sensible really. The Showmen's Guild always used to say that the shooting gallery must be under the control of someone not less than twenty-one years old and also that it had to be a certain depth from the front of the gun table to the first target to stop bits of lead coming back. I think that 18 feet was the limit. Mine's 22 feet back so I'm further back than I need to be.

The targets, they're on an endless chain. In the old days the old shooting galleries used to have a row of bottles at the back to break, or clay pipes or flowerpots. Also we had the ping-pong balls on a fountain. That was a good target. The trouble is that now a ping-pong ball costs about 17p. You can only hit it about three times and then it's knackered and you have to throw it away. You couldn't really afford to do it any more, not at 17p each.

My grandfather had muzzle loading guns on his stall, black powder guns. He made his own lead balls. He'd just boil the lead up and pour it into this mould. You dropped a measure of gunpowder down the barrel.

Nowadays you do it with a little flask which will determine how much powder you drop in but according to what my dad said my grandfather used to have a bent spoon and a bucket. You just took the bent spoon with the powder in it and you held your hand round the muzzle of the gun to form a sort of a funnel and you poured the powder down there and gave it a bit of a shake. Then you'd take the ball, you'd put that in and instead of ramming it down with a ramrod as you would normally you just thumped it down on the ground and that bedded the ball into the powder just sufficiently to give it enough power to shoot the ducks down or whatever it was on the shooting gallery. Then when you'd done that you pulled the hammer back on the gun to cock it, and you put a little cap on the nipple of the gun and then you gave it to the customer who shot it. You took it off him and went through the whole procedure again. You did it three times for tuppence, that's 2d. After the chap finished shooting he was entitled to wash his hands because he got his hands soiled with the black powder. Although he'd only spent tuppence with you he washed his hands with your soap and water and dried his hands with your clean towel.

From a conversation with Tony Spurrett, May 1995

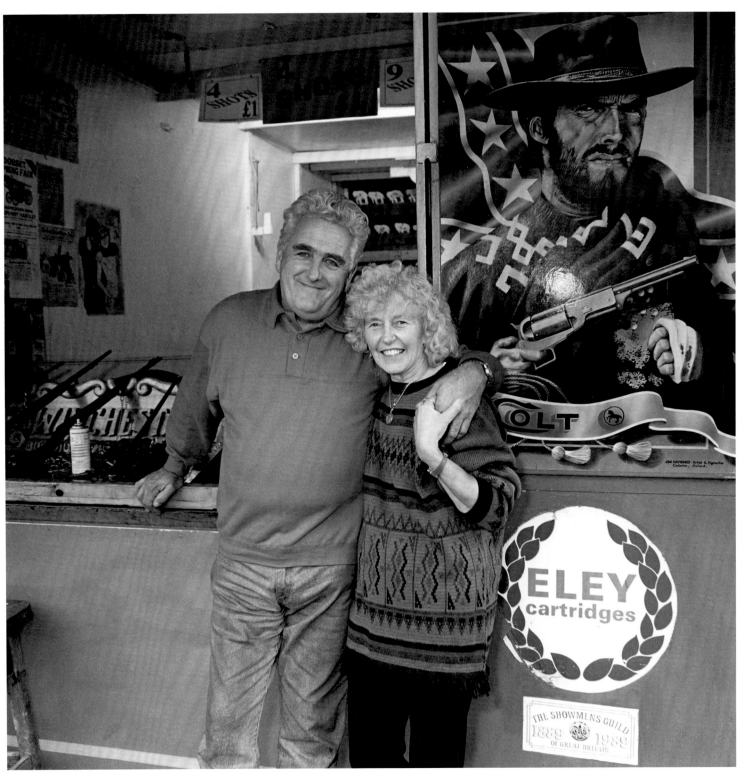

Tony Spurrett and Brenda Hayward
Thame Show Fair 1992

Before Vera and I got married, whilst we were courting, after I came back out of the army I made myself a stall. It was a darts stall and we had that for a few years. I used to travel around with my mother and father. They had throwing games, touch 'ems where you knocked the pegs off, four down out of five, and my father also had darts and hooplas and a juvenile roundabout.

When I first got married I wasn't doing too well with my darts stall so I decided to branch out into the fast food business which was more or less in those days an unheard of thing. I can only remember a couple of people when I went into it that had them, hot dogs. There were no hamburger stalls in those days, just hot dogs. I started off at Cheltenham and there was a local firm there that made sausages and there was a local baker there that made very very good rolls. In those days the sausages were done up in fours, threddled through in one big line of them and they used to hang over the back of the stall on a rail. As you wanted them for the pan you used to cut them off and put them in. You couldn't do that today.

After I got elected to the committee of the London Section, because I was a tenant showman in Thame and also Oxford, I was asked would I be a steward. The stewards are for the betterment of the fair and the easy running of the fair and a quiet sort of progress all the way through the fair. We don't want problems, we don't want troubles. None of the showmen want that. If the council decide that they want something or other, they go hunting out for the stewards to try and sort things out. If we don't get things right then the people get called on complaint and they get dealt with by the Section. Well you do what you can because you're there to help your fellow members, you're not there for your own benefit. You're there to help your fellow members albeit its sometimes detrimental because you have to neglect your own business. But then when you take the job on you've got to do it to the best of your ability and I think that is one of the things I've always tried to do.

My parents weren't fortunate enough to be open through the war because my brother Victor was a fireman at Wooburn Green, and I was in the army. And my younger brother Stanley wasn't very old so he wasn't capable of driving a vehicle.

Travelling people like everybody else were supposed to report. I knew that I was likely to go in the forces like loads and loads of other showmen. Lots of people went. Even where I went – I went to Cleethorpes – whilst I was walking down the front much to my surprise there was a fellow showman from the London Section. And we finished up in the same company, me and Alfie Burdon.

I was fortunate, I did come back. But like father said to me when I was going, he said, "Son if the Lord wants you to come back you'll come back and if he doesn't you won't. You will go and be a man." He was one of six brothers and he was one of the three who came back after the 14-18 war.

And I go up now to the Armistice Day parade in London. Since I've started going up there, there's more and more ex-servicemen of the Showmen's Guild coming year after year. It's an honour to be on the parade after you've done service especially if you've done service overseas and you've lost some of your friends and your mates. In the time that you're stood in Whitehall more or less the whole of your army career flashes past the front of your eyes, you see all the people that you knew. You always feel about ten foot tall, always, and in Whitehall, for anybody that's never been there, when the first gun goes off for the silence the world stands still. The only thing you can hear is the rustle of the leaves coming off the trees, that's all you can hear. I wouldn't miss it for the world.

From a conversation with Henry Farr, December 1997

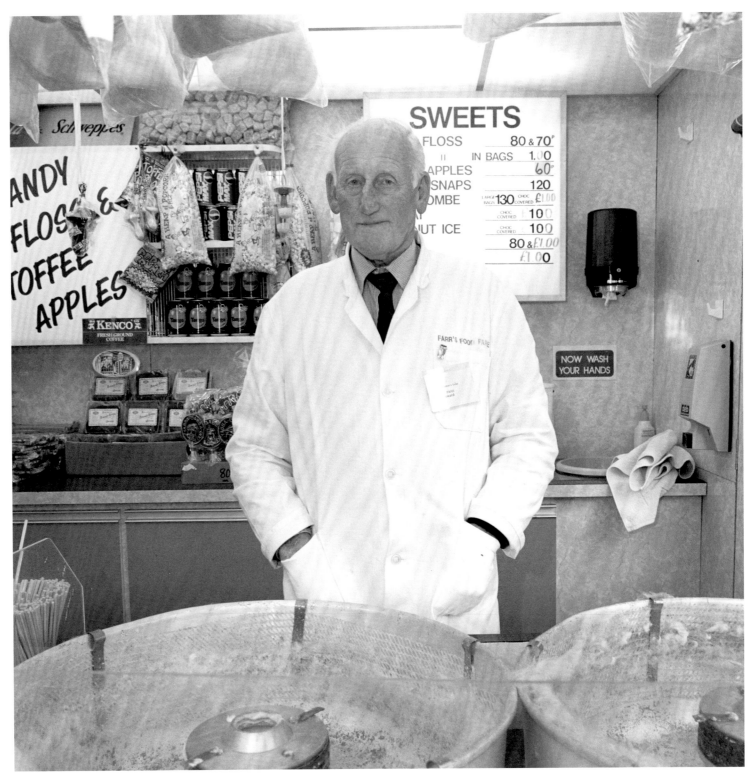

Henry Farr
Thame Show Fair 1994

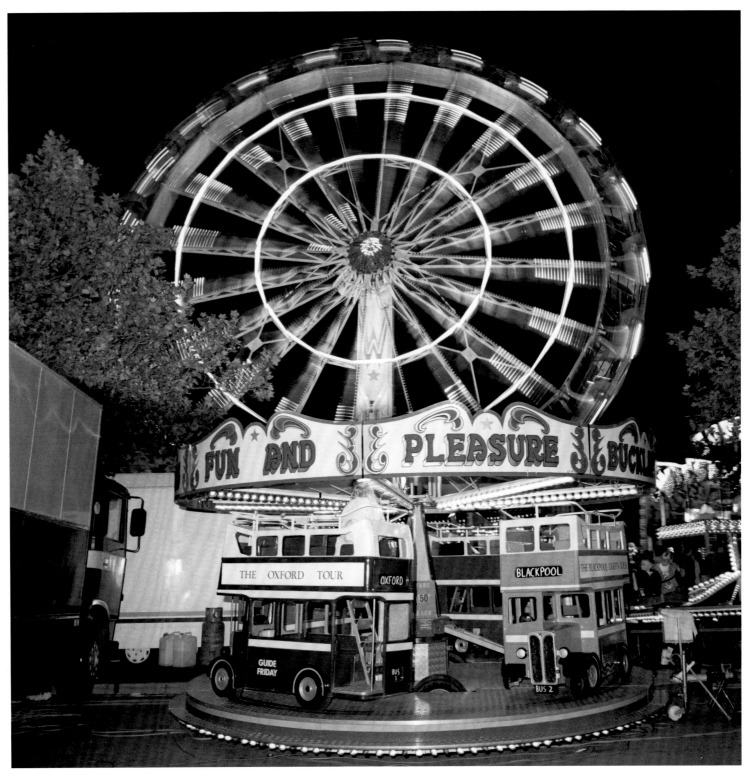

Nathan Buckland's Juvenile on Edward Roberts' ground (Wilson's Enterprise in background)
Thame Show Fair 1995

Street

Trailer and Yard

Celebration

Trailers, Aylesbury Road Field, Thame
Thame Show Fair 2000

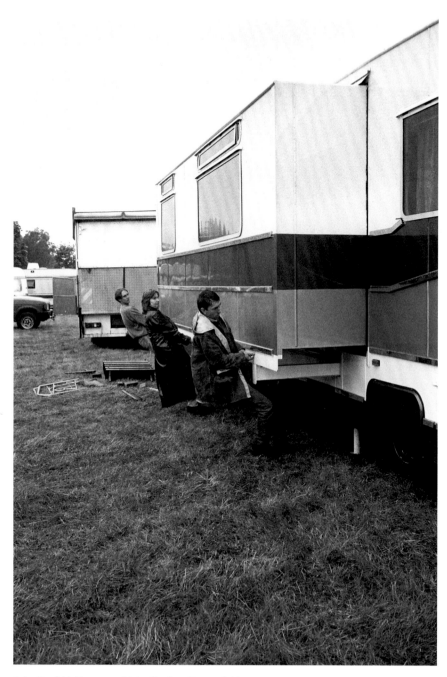

John Penfold, Sharon and John Rawlins, Bypass field
Thame Show Fair 1998

Bypass field
Thame Show Fair 1998

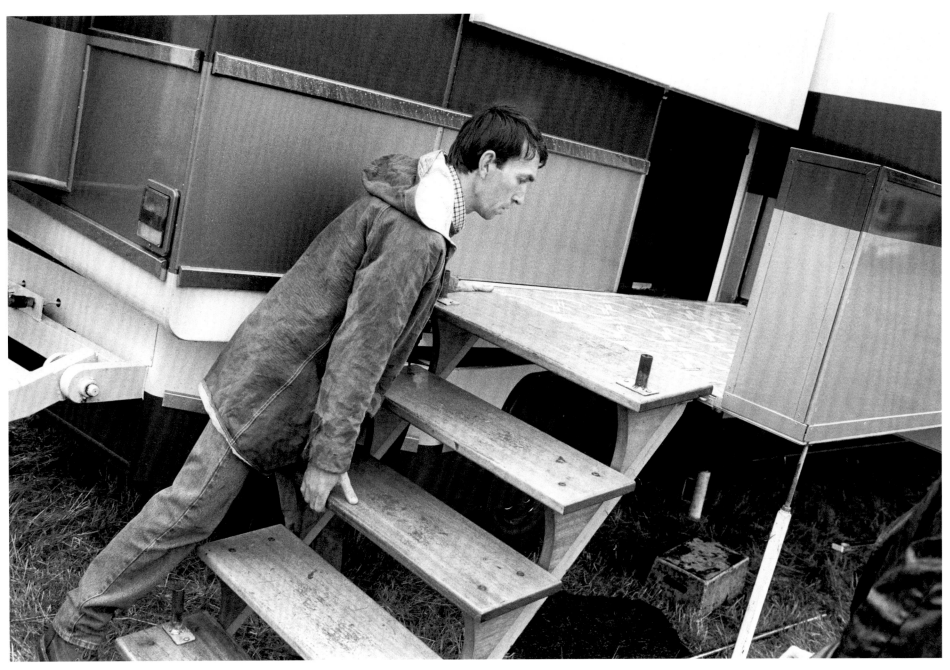

John Rawlins, Bypass field
Thame Show Fair 1998

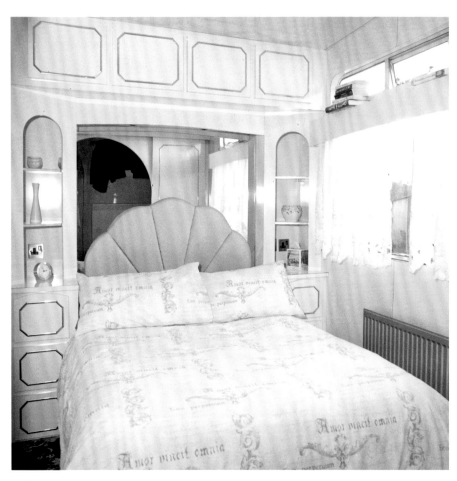

Trailer Interior
Courtesy of John and Samantha Brixton

Trailer Interior
Courtesy of John and Samantha Brixton

Trailer Interior
Courtesy of John and Sharon Rawlins

Trailer Interior
Courtesy of Raymond and Rachael Pearson

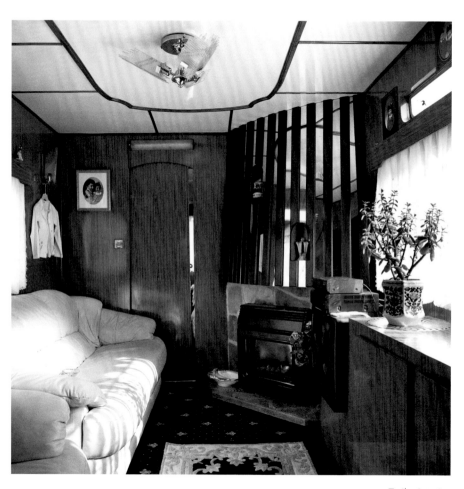

Trailer Interior
Courtesy of Jack and Charmaine Rose

If you think about it, when we go away we have with us the three most important things a man can have, his family, his home and his means of getting a living, they're with us all the time.

Trailer Interior
Courtesy of Arthur and Karen Rawlins

I started working in the traveller education service doing the fairground work in September 1991. I think Thame Show Fair was the first one I actually went round making myself known. I walked up and down first of all hoping that I'd spot somebody or somebody would stop me. I didn't just like to bang on any trailers and say "Have you got any children?"

Most of the fairground children have a winter base that they come back to and a winter school that they're registered with and so in the winter we work with the school and the pupils and with their parents and see what they need in the way of helping them quickly back into school and getting access to the whole curriculum. We also do in service training for teachers about what it's like to have a fairground child in their class. We are making them aware of the family lifestyle, getting rid of a lot of the misconceptions about who the people are and how they live.

Sometimes its done with just staff, sometimes its done with pupils as well. I use photographs quite often where I've got to know families well and have been allowed to photograph inside their trailers. That causes quite a lot of discussion about how you can travel around and have beautiful ornaments and lots of glassware and beautiful cut glass mirrors and things and the fact that they do have washing machines and fridges and microwaves and thick pile carpets despite being in muddy grounds.

Over the years since I started more and more of the children are carrying distance learning work with them. Parents who had to badger a school to provide something for their child to take away, like they used to do before anybody was involved in supporting Fairground children, have seen the quality of the work improve and the support develop. These families have been a really good support to me. When I was explaining it was a new job they would tell me from their experience with their older children what it had been like trying to make sure that they got a reasonable education on the move.

In the summer we go out to the fairgrounds with our work. Most of the children have a boxfile which contains the various equipment that they might need – pencils, paper, scissors, glue and paint — whatever.

Then usually the younger children have books with work sheets that are put together and ring-bound with cardboard covers. There'll be Science, Maths, Geography, History, English. In some areas now the mainstream teacher is putting in a list of the topics that that youngster's class will be following through the summer. I've got access to a couple of resource centres where I can then look for information books to borrow to take to that child.

Over the years I've got to know when and where quite a lot of the fairs are. Some families are very good at telling me where they're going to be. As the families have got to know me, the ones that come in and out of Oxfordshire quite regularly will phone up in the evening perhaps and say "We've just arrived in such and such a place, which day are you going to come out to us?" It's actually really satisfying from a teaching point of view. You really feel they're getting somewhere and mum takes a real interest as well. I like the fact that working in this way gives me much more contact with the parents than working in a classroom situation. I really look forward to the travelling season starting again. I think I've got a bit like the families themselves when they think "Oh good we'll be going away soon!"

From a conversation with Kathy Turner, Advisory and Support Teacher for Fairground and Circus Children in Oxfordshire, June 1998

People say to me that it's a hard life for the children with no schooling. "Oh no," I say, "they have a teacher everywhere they go." "Oh do you?" they say. They're quite shocked at that really.

From a conversation with Karen Rawlins, October 1998

Arthur Rawlins with Support Teacher Kathy Turner
September 1996

Cheryl (and Stanley) Farr, Bypass field
Thame Show Fair 1998

Stanley Farr and Sarah Farr, Bypass field
Thame Show Fair 1998

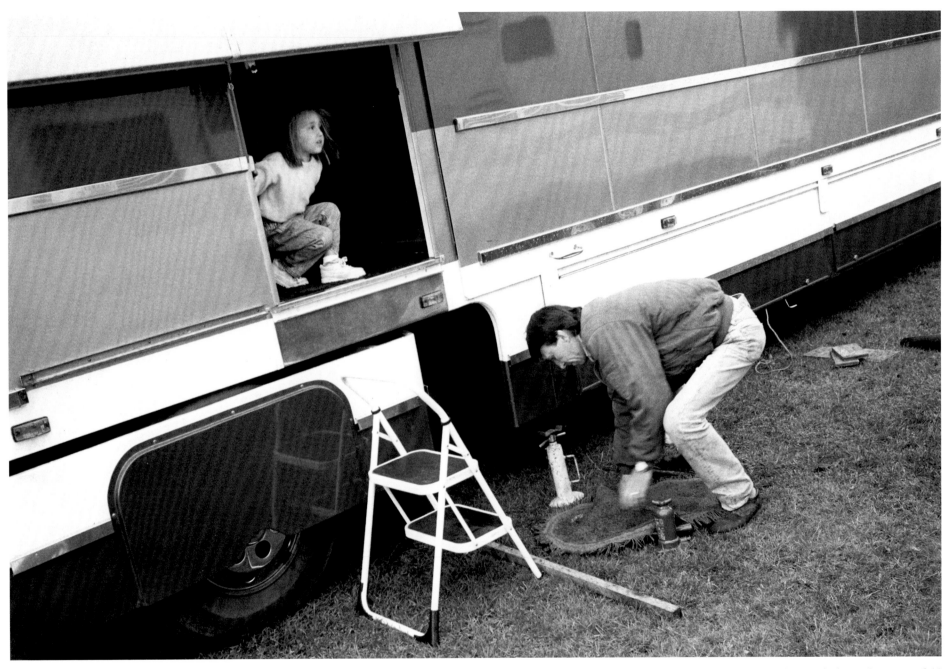

Clarice and John Rawlins, Bypass field
Thame Show Fair 1998

Covered ride
Blue Pitts, March 1995

Silver Cross Prams
Cassington, July 1997

Buses
Blue Pitts, April 1996

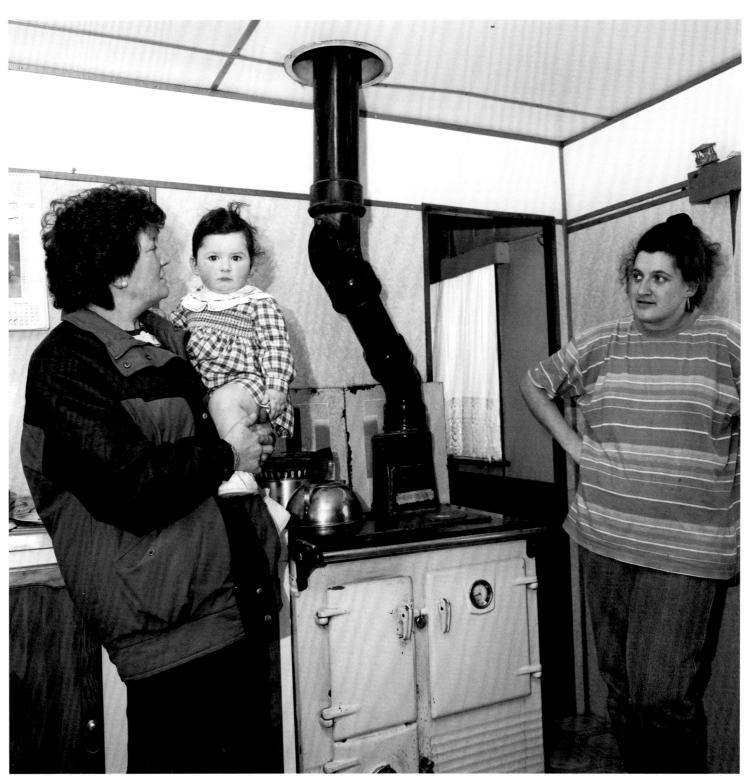

Jackie Rose, her granddaughter Charmaine and daughter-in-law Charmaine
Chalet at Blue Pitts, February 1996

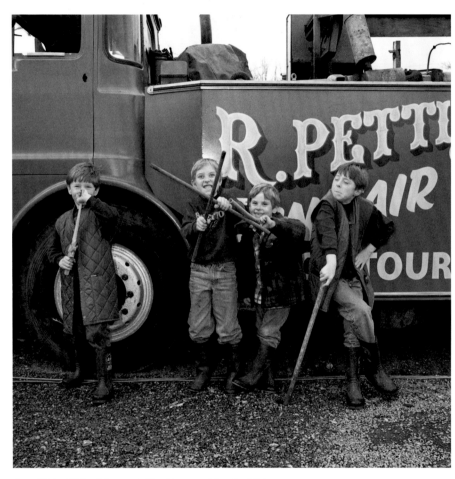

Sean Bibby, Michael Bacon, Ashley Bacon and Bradley Bibby
Brooklands Field, January 1996

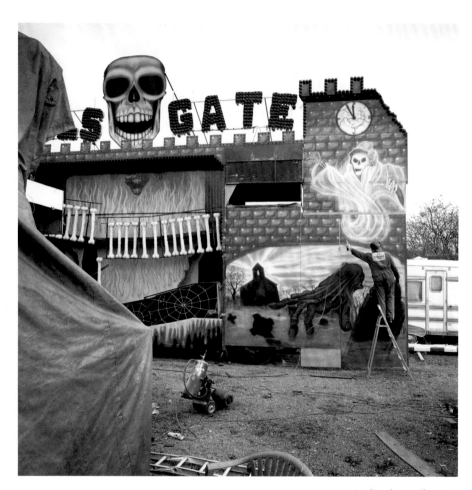

Paul Owles' Hell's Gate
Brooklands Field, March 2000

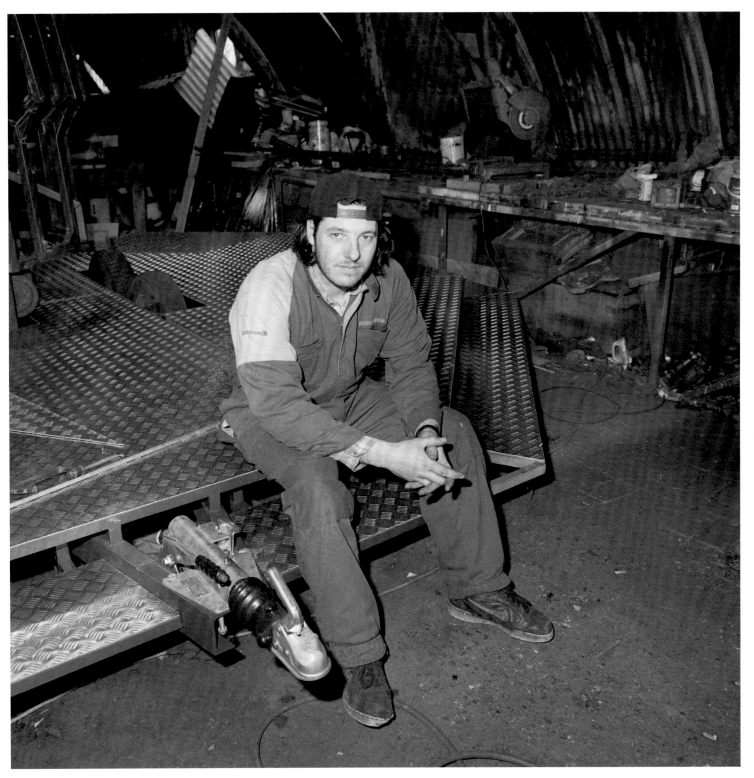

Paul Owles
Brooklands Field, February 1998

Hell's Gate decor Paul Owles' work
Brooklands Field, March 1996

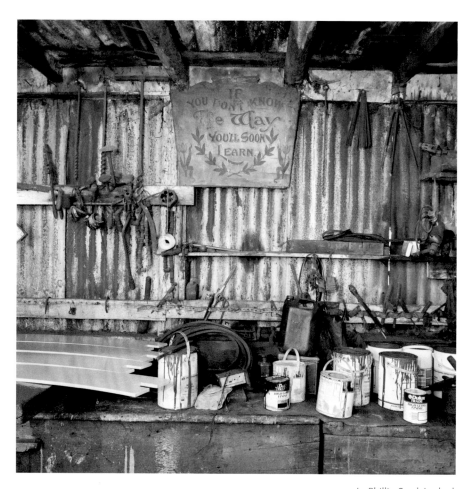

In Phillip Searle's shed
Harlington, March 1996

If you don't know the way, you'll soon learn.

Tommy Wilson's Rolla Ghosta (Mark Gill's paintwork)
Thorpe, March 1997

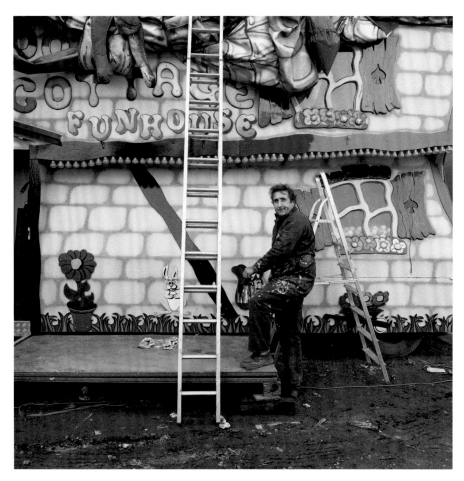

George Wilson
Thorpe, March 2000

Arthur Rawlins
The Plantation, March 2000

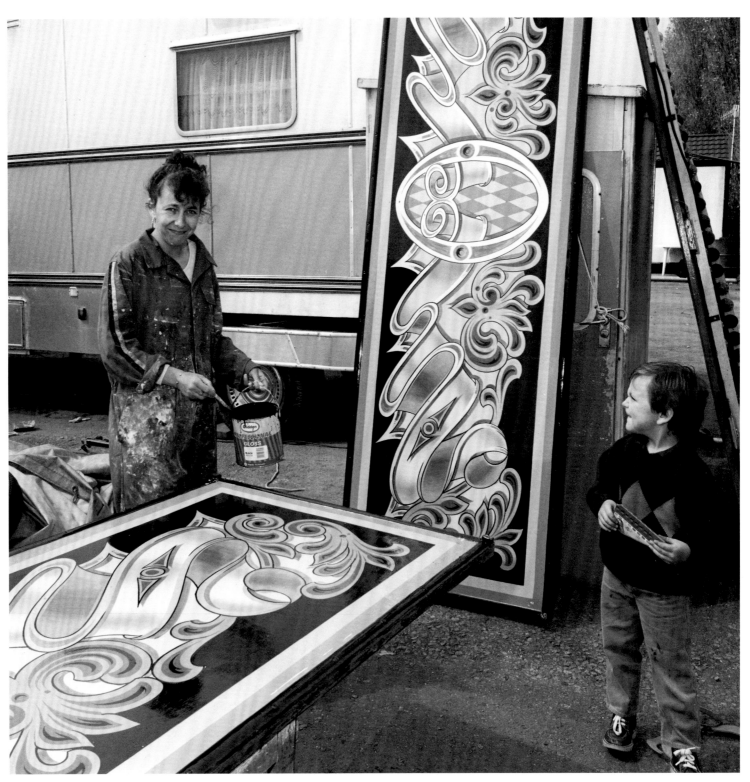

Debbie and Asa Roberts
Banbury, April 1995

Joe Rose and his granddaughter Bobby-Joe Mason
Blue Pitts, March 1997

Joe Rose and his granddaughter Bobby-Joe Mason
Blue Pitts, March 1997

Centre of Juvenile Ride
Blue Pitts, April 1995

I had a Rib-Tickler then. The Rib-Tickler, well that was a single life style, that was before marriage. I suppose most customers were from about seventeen to about twenty-two, that was it, there were no family people, there were no older people. You see it was a teenagers thing, all these young women around me!

Anyway it was quite old, it wanted quite a bit doing to it and when I first got married she said, "No, this is not good! Its got to go!" and I agreed. I got rid of it, and then I had the first hoopla stall made. That was just before we got married and then after that we had one given to us as a wedding present so then we started off with just two round hoopla stalls for three, coming up four years. Then we agreed on having a new helter-skelter made.

Basically I'd helped my sister and my brother-in law a lot with building up theirs when I was a single boy. I wasn't copying my sister but it was something that had been in my past that I knew I could do, I could build a slip and not worry too much about it. Of course you do worry because you risk your life every day you do it. If you fall off there's no in between with it, that's it. But it was something that I could do and that's why we decided to go for the slip.

Originally the plan was to have all new but personally I can't afford to have all new. So I looked to try and find myself a set of axles, second hand ones. Just by chance we were open at Farringdon with Harry Hebborn. We were having a cup of tea one day and Harry said, "Robert Nicholls has got a set of axles for sale. They're in Edwards' yard." So I rung Robert up and agreed on the price and picked them up straight away. As soon as I had the axles it was all systems go, that was the only awkward part. The chutes I was going to have second hand but with the prices at the time it wasn't a lot more for new so that's what we did. Obviously it's always better to go for new safety-wise.

So we went from there. We all chipped in when we made it, Tommy, Joey, Jack. Old Joey was there every day, every day. The design of the slip is basically all copied off my brother-in-law's apart from a few bits and pieces which was easy, we had something to go from. Whereas he's got a hand winch on his tower, mine folds up with hydraulics. I gain with my gates because the gates are already there where he has to pull his up on a rope.

When we were half way through the job we got the tower finished to a certain stage but when it came to fitting the legs to put the chutes on it was an all in the air job and everybody had a bad head for heights except for me. We hired one of those cherry pickers. This one particular day we were welding some brackets round the front where the canopy is and old Joe's watching what we're doing and he's making sure we're doing the job right. Anyway he gets up on the back of the lorry to tell us to move this piece of steel and stands on the lever and sends us straight in the air ...aaoaooh! frightened me to death! The lever stuck and it just kept going up and up and up and up till it came to a stop the best part of sixty feet in the air which was not very nice. As much as I don't like forty feet, sixty feet's quite a way. We laughed about it afterwards but at the time it wasn't funny.

I'll build up the helter-skelter, I'll build up my stalls just to go to a fete. I'll take the chance. That's what you've got to do, you've got to take your chances, that's the only way to get on. In any walk of life you got to have a goal, you've got to have something to keep going for. I'm doing it for myself at the moment but in the back of my head I'm also doing it for my family. I want us to have everything nice around us, I want us to be comfortable when we're older. Also I don't want my kids to have to go from nothing, I want them to be comfortable as well. If Bobby-Joe finds herself a young man one day then I've got to pay for the wedding, it doesn't come out of nowhere you know!

From a conversation with Jonathan Mason, 29th May 1998

Jonathan Mason's Slip
Blue Pitts, November 1995

Jonathan Mason's Slip
Blue Pitts, January 1996

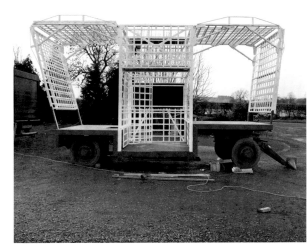

Jonathan Mason's Slip
Blue Pitts, March 1996

Jonathan Mason's Slip
Blue Pitts, April 1996

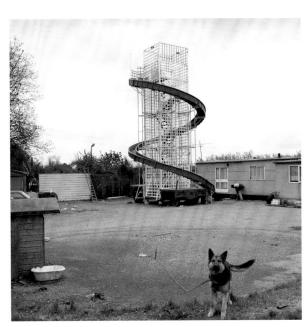

Jonathan Mason's Slip
Blue Pitts, May 1996

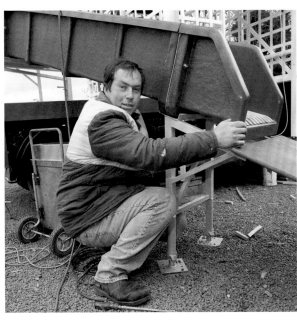

Jonathan Mason
Blue Pitts, May 1996

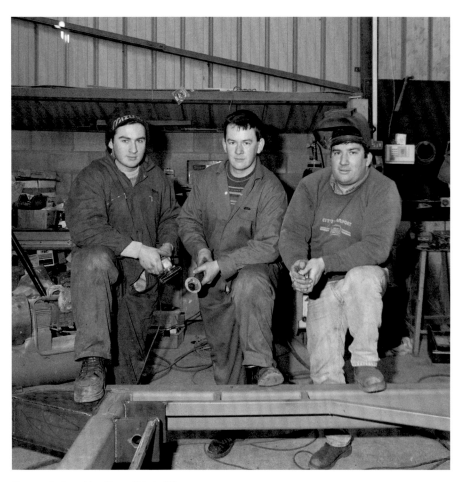

Tommy, Jack and Joe Rose, Ride builders
Blue Pitts, February 1996

Centre for Juvenile Paratrooper ride
Blue Pitts, July 1995

Rebushed the centre, repinned the main arms, repinned the ends of the arms, put new grease nipples in the ends of the arms, checked all the brush gear. Checked all the main ram, checked the main pivot on the centre and bushes in the top, and the main locking nuts. Resprayed the arms, the poles, the centre; shot blasted the cages, had them zinc sprayed, anodised, undercoated and glossed. Ground the truck completely back to the metal; took both engines off and went right through the engines, did all the brakes, the springs, rewired underneath the pay-box, the top of the pay-box; did the signs completely.

Went right through the ride and made it all like new again, and put it all back together.

Had it out for six months and the main gear went in the middle. That was at Eynsham.

John Brixton on his Meteorite overhaul, Winter 1995/96

John Brixton, Meteorite overhaul
Mill End, January 1996

In Tony Spurrett's shed (Hostess Stove)
Carterton, February 1995

The stove? It was originally bought from Albert Edwards. They had had it in their caravan for many years. It's a coal fire, a small coal fire. The actual fire was probably six or seven inches wide and about a foot or so deep, the full depth of it. There were two little rings in the top, one on top of the oven and one straight over the top of the fireplace and whoever got up first in the morning used to light the fire and put the kettle on. See, you cooked on it as well as heating the wagon. It did everything. And there's a rail round the top there that used to stop the kettles coming off on the road. And this little cage round the front of the fire, mum used to lodge the bread in there to toast it. All that front which is now covered in a sort of thick grease is chromium plated. She used to shine and polish it when it was in the wagon. It was in that wagon I built, the one that my dad died in, that four-wheeled caravan. Hostess stoves were very popular and all the original showmen's caravans had Hostess stoves in them. And at one time you could see in World's Fair 'FOR SALE – Hostess Stove' and it used to be quite a lot of money. Some of them used to have little tiles round the back with Dutch boys and things on but ours didn't have that, it was a very plain one.

From a conversation with Tony Spurrett, May 1995

I mean another really good reason for me wanting a three cylinder Gardner is that they're getting a bit sought after now. Everyone would like one but can't find one. Or if they find one it's too dear anyway. I had a Gardner engine before, a four cylinder, but with having only just the two juvenile rides the four cylinder was a bit too big really, and well I just like Gardner engines. Dad's always had Gardner engines. I bought it from a scrapyard near Aylesbury. I just cleaned it up really, painted it. The aluminium has been bead blasted and polished and I made a bed for it to sit on. It was standing for about twenty five years before I used it. The generator that I've mounted to this runs at 1500 revs and I didn't want the engine running at that sort of speed so I've got a series of pulleys. I just calculated the fact that I wanted the engine to run at about 1200 revs so I bought pulleys and belts to suit. The generator's mounted above the flywheel. Instead of being in line it's mounted above and we've bolted a pulley onto the back of the flywheel, one on the generator and there we have it. I can run two or three kids' rides and my dad's side stalls.

From a conversation with Jack Rose,
September 1997

Jack Rose's Gardner 3LW (as purchased)
Blue Pitts, January 1996

Tank
Mill End, December 1995

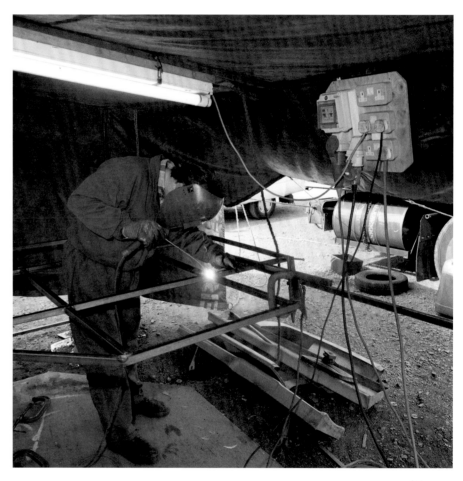

Raymond Pearson
Fairacre, March 1998

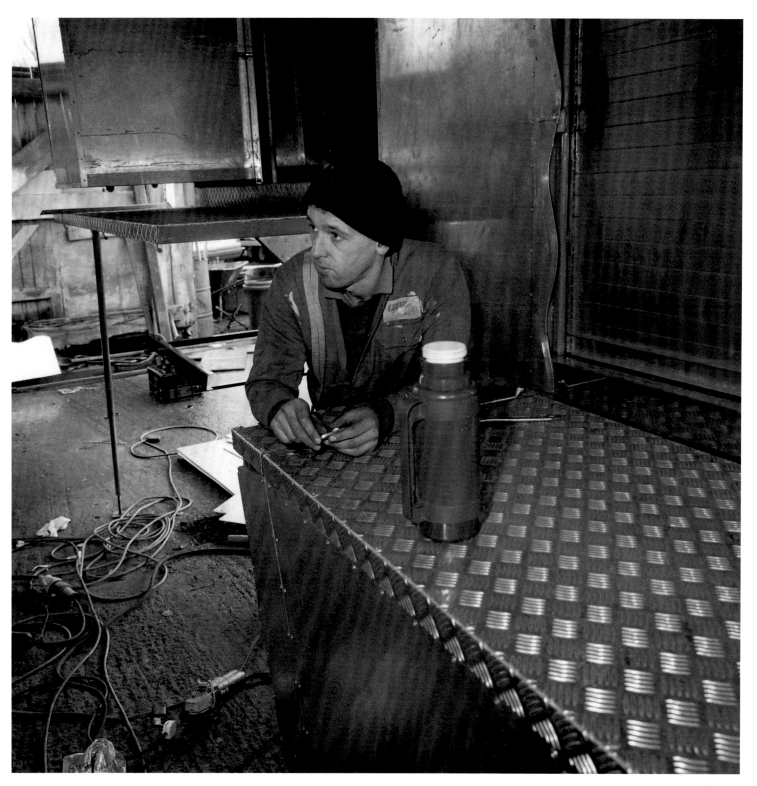

Stanley Farr
Mill End, January 1998

That's the hardest part, getting a full circle. It took me ages to figure out how to do it. And the best way I found is to use my hand as a pivot, find the radius and just follow it round. I used to try it this way, I used to try it that way but always wander off course. I do the same thing for drawing, I use my hand as a pivot. And that's how I've learnt how to do it.

Simple when you find out how.

Lots of people say, "Oh how do you do it?" but like I said, it's all in the mind, you know what you're going to do. My mum'll sit up here and she'll say "How do you know where to fill in, how do you know where the lines go?" And I said "Mum, how do you know how much ingredients to put in a cake?" It's experience, isn't it. I said, "I couldn't bake a cake like you can't paint this painting, it's the same thing." That's all it boils down to, you just know what you're doing.

You see you work from the back forwards if you get what I mean, you build it up in stages. So I spray the border in first then do the background of the letter, then the shading. When you do the shading first, if you overlap the background of the letter it doesn't matter because when you line the letter you straighten it all back up. So if you work in those stages it's much easier. And colours are the main thing, knowing your colours. I mean can you put one colour on, you can put a green on, but you put the wrong shade of green on and it all totally changes. It'll look wrong entirely. It's knowing the right shade of green or the right shade of red or of blue or whatever. You put the wrong shade of the same colour and it'll look totally different. It'll look either too heavy or too light. At the moment this looks all of a jumbled lot. It's never finished till it's finished, till you put that last line on that finishes everything off. Hopefully you can have a picture then.

I was like my boy John is now when I was a kid. John would much rather be up the trailer doing a bit of drawing or colouring or playing with his Lego than go outside and ride his bike and that's how I used to be looking back on it. My dad always used to be fiddling about with something or another. He was never a painter like me but he could put a line on and do a bit of filling in and make something look something. I was always watching him and I just picked it up, it clicked.

The first job I did was a Hoopla of my dad's. Arthur's got it now. The first work I did for somebody else was for Monty Forest, the joints he's got. That was the very first work I did for anybody else. And I've done that much now I couldn't tell you what I have done to be quite honest.

But where I made a big mistake – I think I told you this before – when I started painting and I got into it, Hall and Fowle's advertised for apprentices. And different ones said to me "Oh you ought to just go and work for Hall and Fowle." "Oh no, no, I couldn't do that," I said, and that was the biggest mistake I made because what's taken me all this time to learn – and I'm still learning now, techniques and one thing and another – what's taken me all this time to learn I could have learnt in the course of a couple of winters.

That was a big mistake on my part. But you learn by your mistakes don't you.

From a conversation with John Rawlins, January 1998

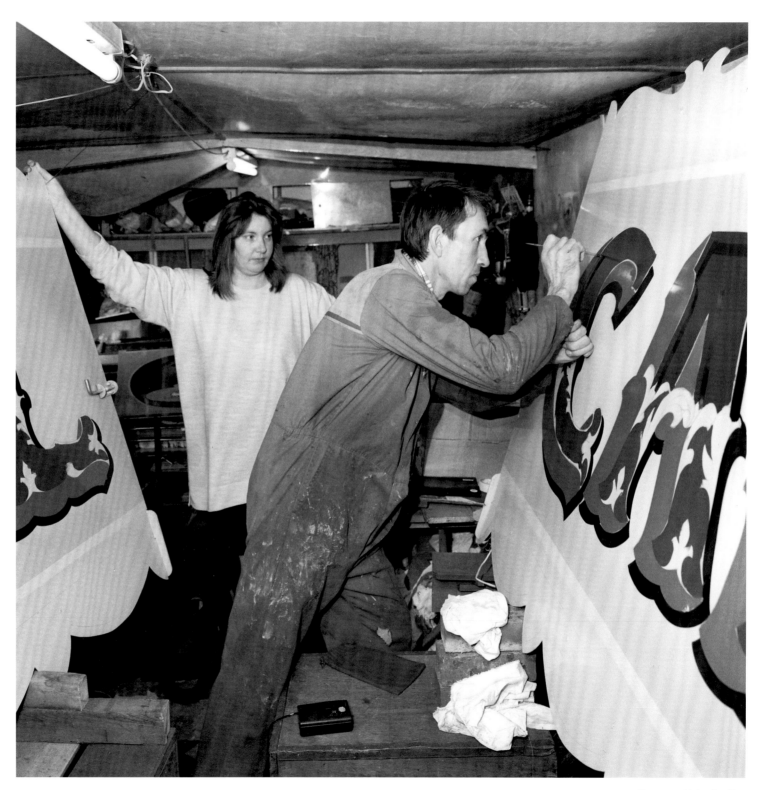

Sharon and John Rawlins
The Plantation, January 1998

Street

Trailer and Yard

Celebration

John Rawlins
The Plantation, Clarice's Christening, March 1997

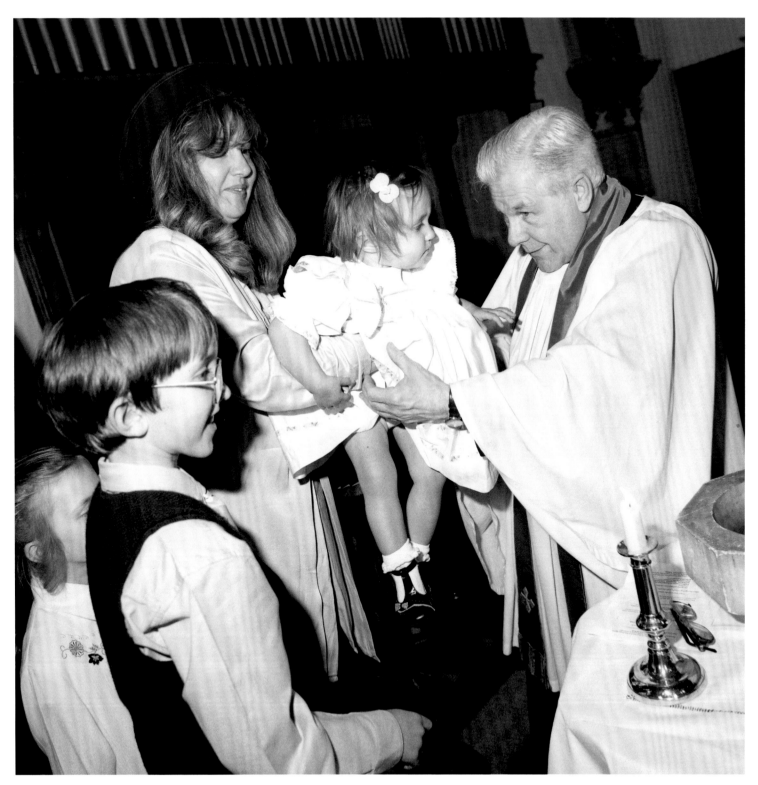

Clarice Rawlin's Christening
Horne, March 1997

Scarlett Forest held by her godfather Jonathan Mason with his daughters Sherelle and Bobby-Joe
Witney, November 1999

John Woodward and his son John
Candice Pearson's Christening, February 1997

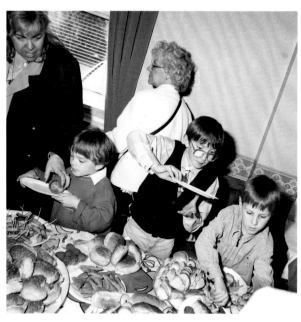

Clarice Rawlins' Christening party
March 1997

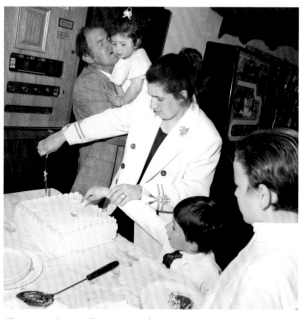

Charmaine Rose's Christening cake
April 1997

Candice, Samantha and Whitney
Candice's Christening, February 1997

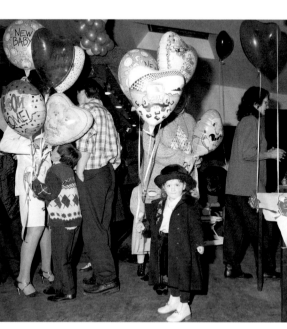

Bobby-Joe
Candice's Christening, February 1997

Jack, Edward and Ray
Candice's Christening, February 1997

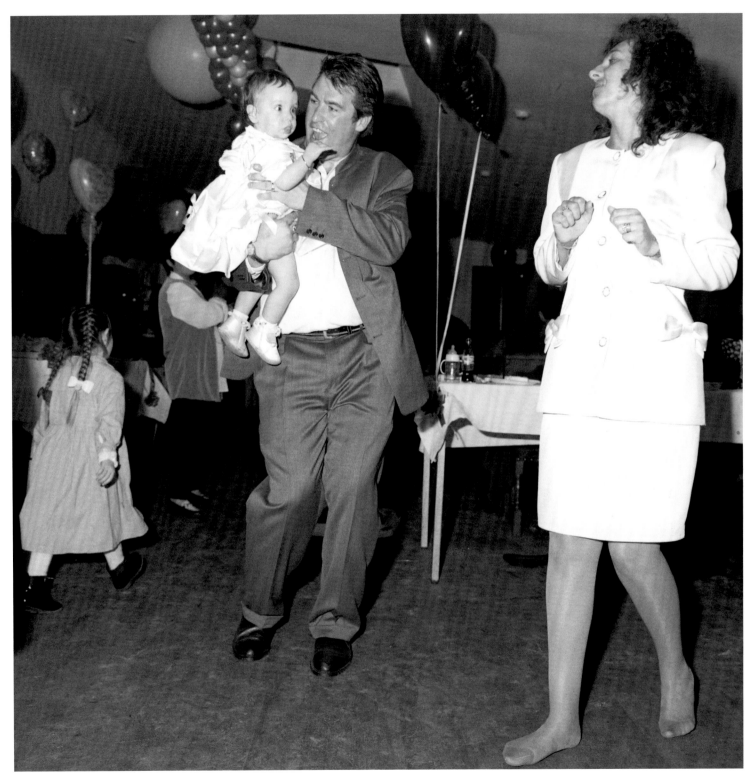

Candice, Raymond and Debbie
Candice's Christening, February 1997

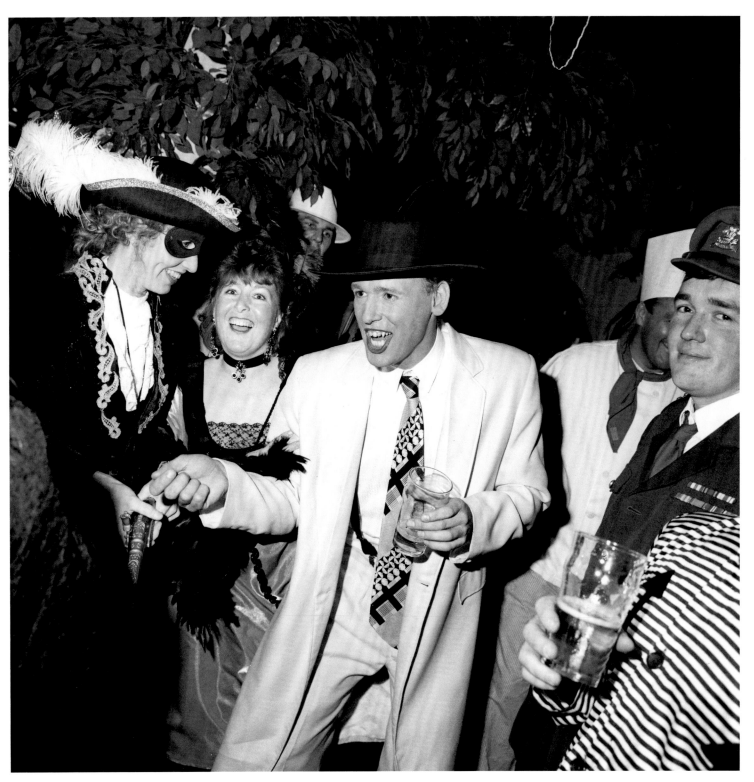

Samantha, Cheryl, Stanley and John
Fancy Dress Party, January 1998

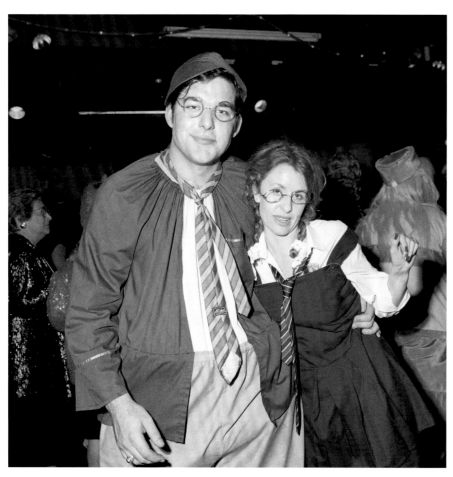

Elliott and Lisa
Fancy Dress Party, January 1997

Carlie and John
Fancy Dress Party, January 1998

Arthur
Fancy Dress Party, January 1998

Sylvie, Gordon, George and Judy
Fancy Dress Party, January 1998

George and Gloria
Fancy Dress Party, January 1998

I mean life's for living isn't it, that's
the way I look at it. You've only got
one life. You only go through it once.
We aren't going to come back are we?
You've got to make the most of it, haven't
you, while you're well enough, young
enough, fit enough to do it.

That's all I can say really.

From a conversation with Tommy Wilson,
September 1997

George, Phillip and Tommy
Fancy Dress Party, January 1997

Phillip
Jason Hebborn and Claire Smith's Wedding, February 1996

George and Sylvie Rawlins
Their daughter Lisa's Wedding Day, February 1998

Lisa
Lisa Rawlins and Elliott Burdon's Wedding Day, February 1998

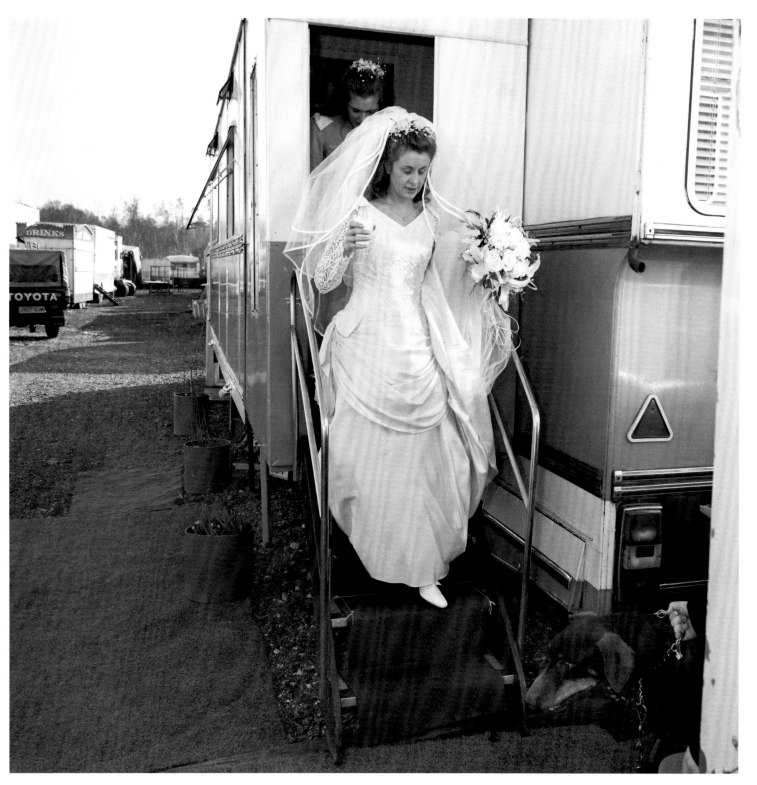

Lisa
Wedding Day, The Plantation, February 1998

Leonard and best man Andrew Crole
Leonard Cohen and Georgina Roberts' Wedding Day, December 1995

Harry Farr
Wedding Day, July 1996

Sammy Mayne, John Wilson and John Penfold
Claire and Jason's Wedding, February 1996

Rhoda Searle, Mark and Rebecca Roberts, Charmaine Farr,
Stacey and Robert Ayers
John Penfold and Carlie Wilson's Wedding, January 2000

Linda and John Penfold
Their son John's Wedding Day, January 2000

Susanhah with her father Henry Farr
Wedding Day, November 1996

George and Emily Crick arrive at their grandson's Wedding
January 2000

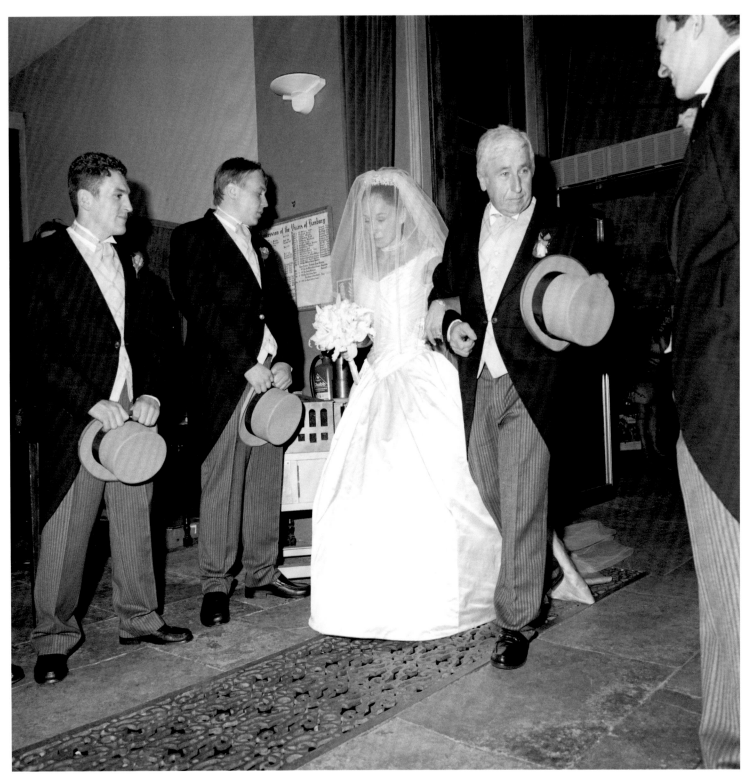

Carlie with her father Tommy Wilson on her Wedding Day
January 2000

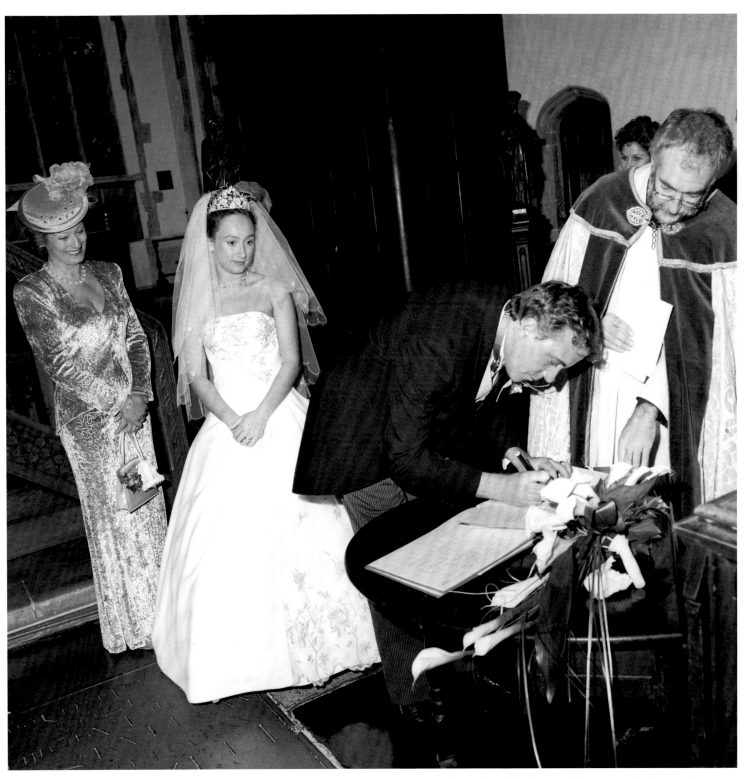

Rhoda Searle watches her son-in-law Robert Wheatley sign the Register
Rhoda and Robert's Wedding, January 2001

Jason and Claire's Wedding
February 1996

Leonard and Georgina's Wedding
December 1995

Claire, don't wait till he's settled down in front of the telly before asking him to get the water in, and Jason, if she's not right behind you on the road remember she might just have got held up at the traffic lights. (A godmother's advice)

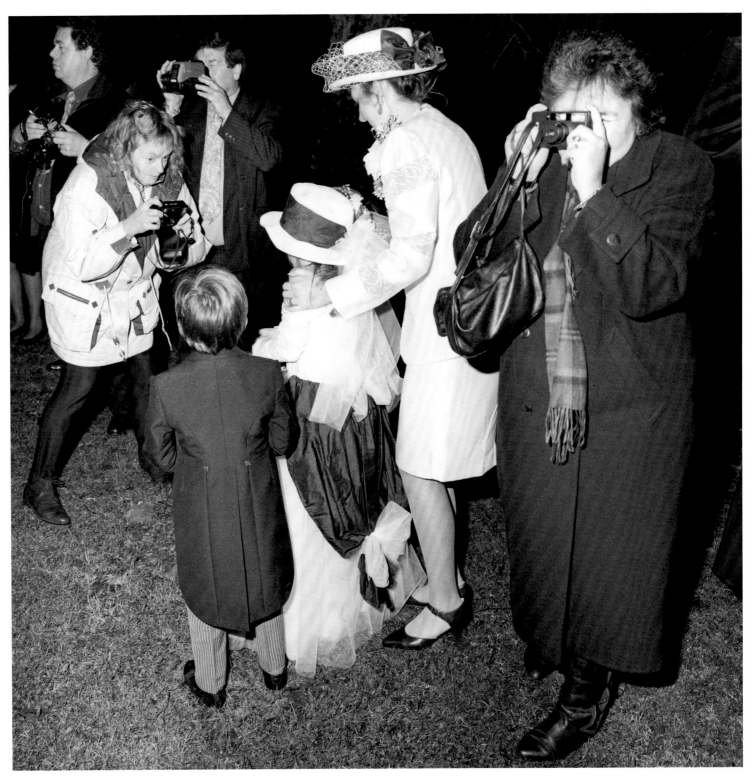

Leonard and Georgina's Wedding
December 1995

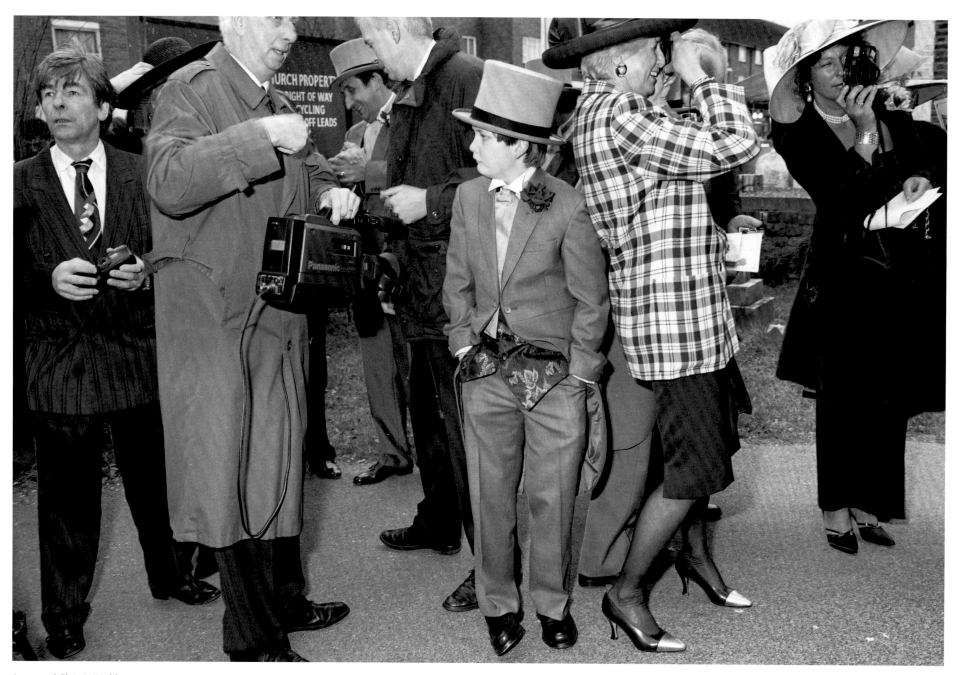

Jason and Claire's Wedding
February 1996

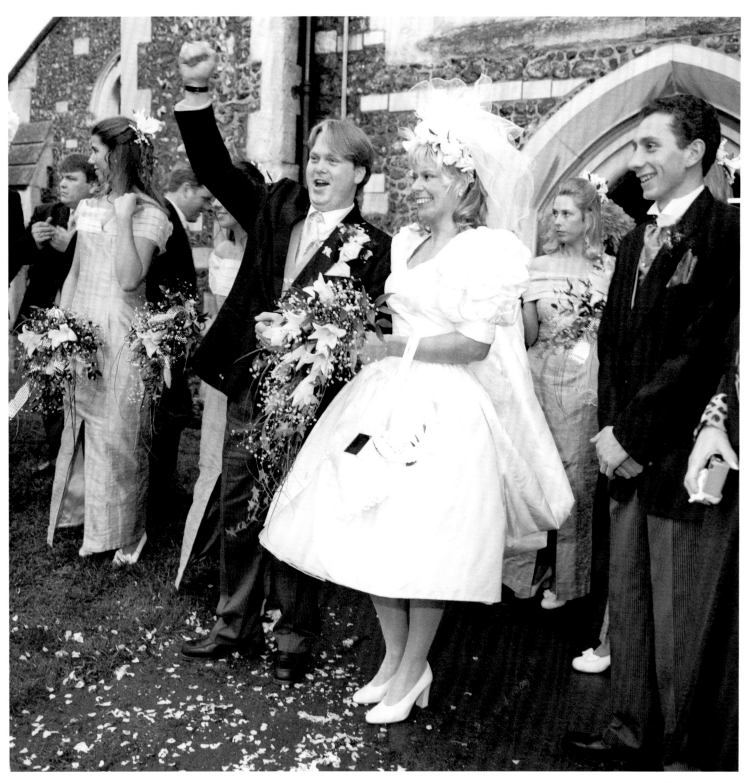

Jason and Charmaine Bailey
Just married, November 1996

Karen, Arthur, Edward and Debbie
Harry and Clare's Wedding, June 1996

Joe and Jackie
Claire and Jason's Wedding, February 1996

Charmaine and Jason's Wedding,
November 1996

Mrs Biddle and Rachael
Sharon and Elliott's Wedding, March 1998

Edward and Debbie
Harry and Clare's Wedding, June 1996

Albert Richards sings at his elder daughter's Wedding
Charmaine and Jason's Wedding, November 1996

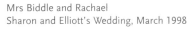

Larissa, Aaron, John and George
Lisa and Elliott's Wedding, February 1996

Louise, Helen and Clare
Clare and Harry's Wedding, June 1996

Clarice
Lisa and Elliott's Wedding, February 1998

Harry and Clare's Wedding
June 1996

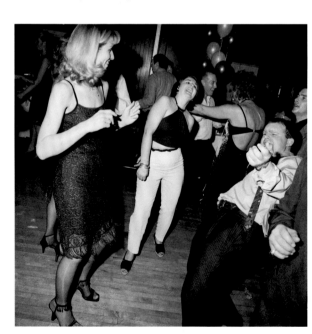

Samantha and John
Sharon and Elliott's Wedding, March 1998

Susanhah Day nee Farr,
Wedding Day November 1996

Ronnie Williams, Dennis and Betty
Brian and Bobby Stacey's Wedding, June 1997

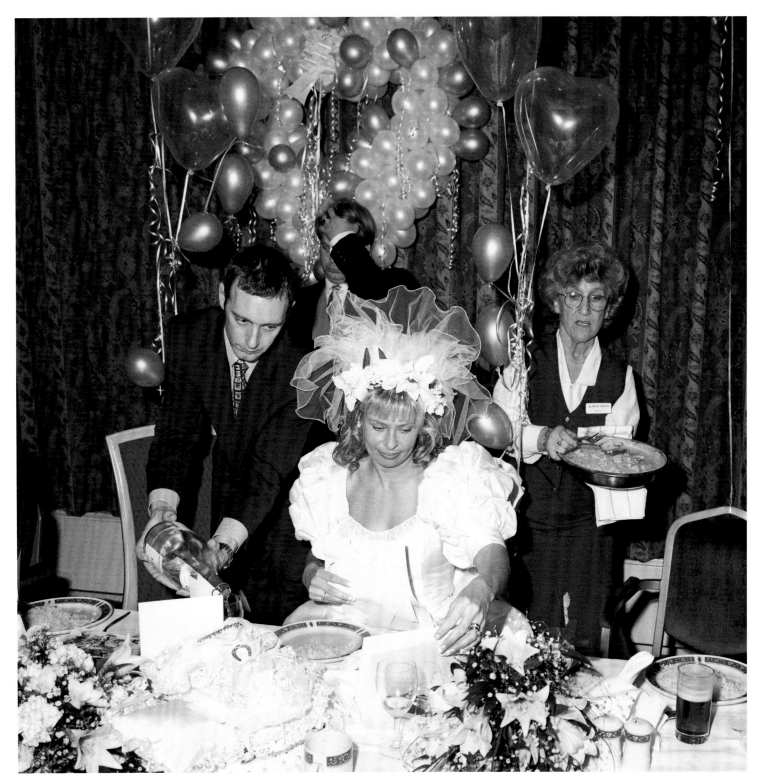

Charmaine Bailey nee Richards
Wedding Day, November 1996

Bear, Susanhah and Alex
Harry and Clare's Wedding, June 1996

Bailey Farr, Frances and Harry Parkin
Harry and Clare's Wedding, June 1996

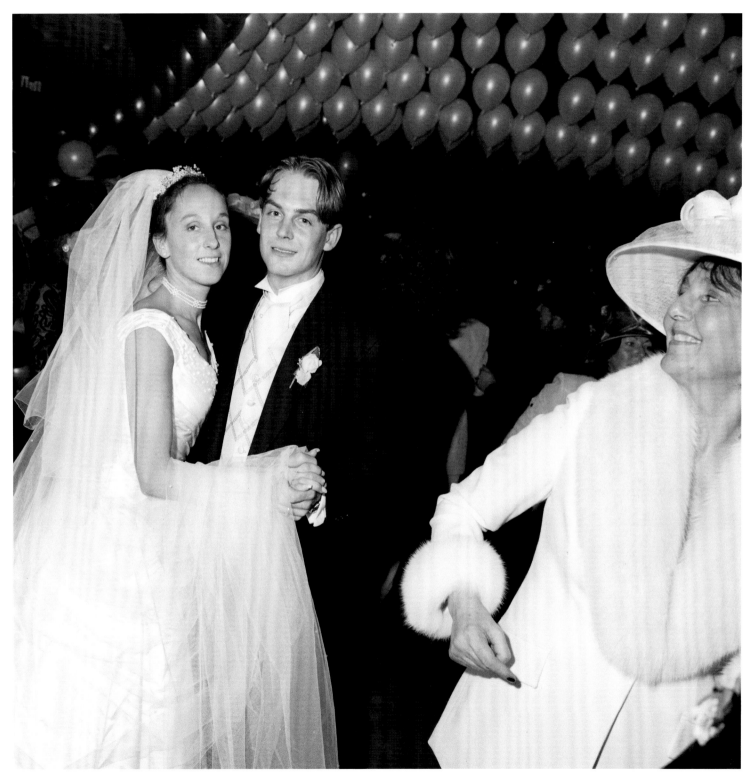

John, Carlie Penfold and Carlie's mum Eileen
John and Carlie's Wedding, January 2000

Simone and John
John and Carlie's Wedding, January 2000

Fairground Attraction

John Comino-James

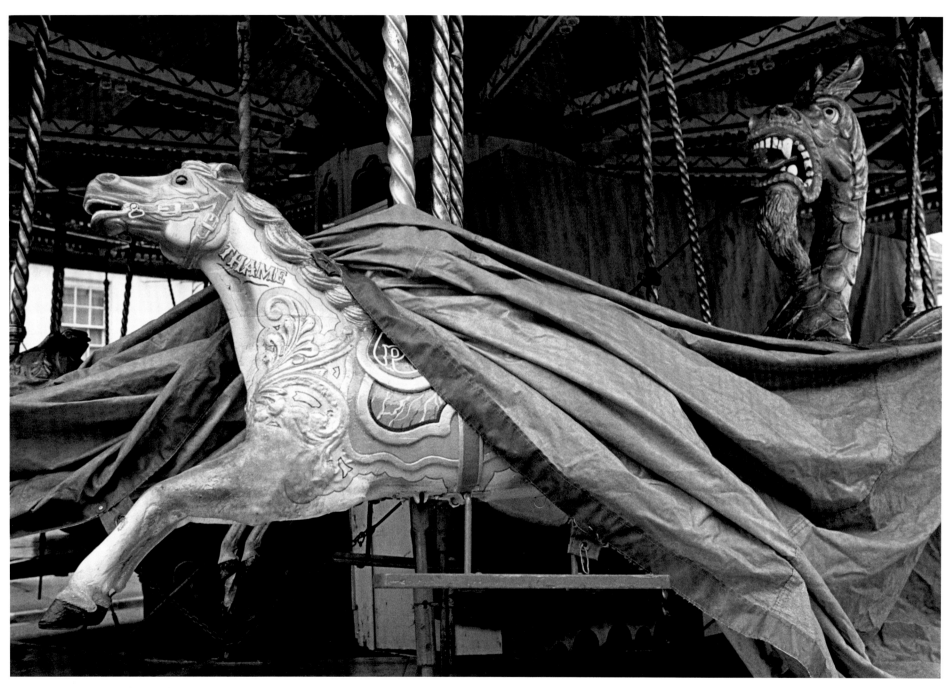

Mrs Sandra Pettigrove's Tidman Gallopers
Thame Charter Fair 1995

First encounters

"We get a lot of people taking photographs of the equipment, or while we're building up, but nobody really talks to us."

In a bleak and exposed field outside the bypass, I watched and photographed as showmen arrived for Thame Show Fair. They were not the first arrivals. Other trailers had been set a few days earlier, tight to the boundary fence. There were four-wheel drives, pick-ups, and generators. Washing lines had been erected, dogs tethered. A stand made of a lorry wheel supported a satellite dish. A few trucks and folded rides were parked up opposite the gateway.

I photographed as a child peered out of a trailer, the doorway half concealed by the folded-down roof of the step and porch, and I made further photographs as her father busied himself, emptying belly boxes of the packing and steps and the jacks that would be needed to level the trailer. It mizzled with rain and the work would be done as quickly as possible, to a routine so familiar that it could be carried out in daylight or dark, whatever the weather. I remembered the interior of the same trailer when it was a bare shell. I had been present on a March afternoon when the little girl I had just photographed was christened, along with two cousins, before the families pulled out from their winter quarters for the summer's travelling from fair to fair. I had known the family since before she was born and that winter she would be starting school.

Nearby three generations of another family were arriving. Son, father, and grandfather set the extended family's trailers close to each other, inching them onto packing, checking for level, and dragging out the pullouts that expand the interior space. We all knew each other but there was no spare energy or time for chat beyond a greeting. It was Tuesday morning and they had all had been open with the fair at Witney Feast until late the previous night. This morning they had packed up their homes and moved here. When the trailers were set, water carried, and toilets built up they would return to Witney to open for the late afternoon and evening. Tonight after closing they would pull down their equipment in darkness and come back here. There would be a few hours rest before building up in the High Street for Thame Show Fair which would open on Thursday.

I first experienced this particular fair in 1984. We had recently moved to the area and one of our new neighbours grumbled a warning that normal access to the town centre would be impossible. There was a lot of rain that week and the showground became a mudbath. Later, preparing to write these words, I would read that Peter Barnes, recording the fortunes of the fair and the showmen for *World's Fair*, reported that *"just when the Saturday night crowds should have been pouring into the fair the rain poured down instead."*

But on the Friday it was dry enough for a family outing. At the fair I dared a ride on the Meteorite. Although I have a vivid recollection of being pinned by centrifugal force to its metal cage and of whirling above the street somewhere near The Bookhouse, I have no recollection at all of handing over my fare; eager at the prospect of the experience (or simply apprehensive) I had hardly spared a glance for the person in the paybox. I would remember this a few years later when a showman remarked, *"We get a lot of people taking photographs of the equipment, or while we're building up, but nobody really talks to us."*

A year or two later I took photographs, a few panoramic images of swirling lights trailed out through time exposures. One even included the words *DARE TO BE SCARED*, the sign on the Meteorite, but they were safe images from a safe distance: photography without engagement.

For the real involvement did not begin until I was watching the fair arrive in 1989.

In a photograph taken then, a boiler-suited man carries a carved and decorated roundabout horse on his shoulder, his face obscured by its bulk. The choice of viewpoint had far less to do with creating an image of heavy work being done than with my own desire to remain unseen. As I watched, a voice from behind challenged me: *"Take a picture of me then!"*. When I turned, caught out and challenged, I was confronted by two men, one of whom had drawn himself up posing for a photograph which I then could not avoid taking.

Next day at the other end of the fair a showman, Tony Spurrett, drew me into conversation. He was minding what I subsequently learned was the last live ammunition shooting gallery still travelling in the country. Recognising my camera he was intrigued as to why I had taken great pains to conceal the maker's name with electrical tape. My explaining that inch of black tape was the beginning of both a fortunate friendship and an involvement with travelling showmen that has taken me beyond the public, brash, adrenalin charged atmosphere of the fair with its cries of invitation and exhortation — *"Have a try then!"* and *"Somebody Scream!"* — the smell of hot-dogs and onions, the tradition of candy floss, goldfish, and toffee apples, the rumble of generators, and the shrieks of teenagers whirled roof-high through blaring music. It has taken me away from the flashing lights of the fairground to the privacy of trailers, to draughty winter workspaces, to parties and christenings, to the exuberant celebration

of weddings and to the sadness and collective respect of funerals.

It was a fortunate encounter. For until then I knew nothing of travelling showmen. I had no idea that their very particular cultural identity distinguishes them from other travelling people. I knew nothing of the origins or history or the organisation of fairs.

And I had reached middle age quite unaware that I was, to use the showmen's word, a 'flattie'.

An historical perspective

About 200 fairs a week are held in Britain from Easter to November: some are held for one day only, others may last two or three weeks. Some appear on the local park or common almost by surprise, others accompany a local event such as a carnival, and yet others occur on long-established fair dates with names such as Nottingham Goose Fair, Priddy Sheep Fair, or Witney Feast, names that suggest links with the past.

In whatever guise the modern funfair appears, with its traditional attractions like Dodgems, Round-abouts, or Hooplas set alongside up-to-the-minute white-knuckle rides, it has developed and evolved from roots deep in an ancient history of fairs which were very different from today's. The word *'fair'* meaning a 'periodical gathering of buyers and sellers' is derived from the Latin, *'feria'*, meaning a holiday and the older word *'fesiae'* in turn related to *'festus'* meaning festal or joyous, but the tradition has its roots in pagan, pre-Roman, pre-Christian times. Their primary purpose was trade and many of the oldest fairs would have been held strategically on the great prehistoric trade routes such as the Icknield Way. At Weyhill the fair was held where the Tin Road from

Cornwall and the Gold Road from Wales met six other drove roads. When the Romans departed Britain and Christianity became the country's dominant religion, these events would have been gradually adopted into the Christian calendar of Feasts and Saint's Days.

By the Middle Ages the rights for the holding of fairs and markets were in the gift of the King and were granted by Charter to Lords of the Manor or to church or monastic leaders in reward for services rendered. Nowadays the existence of a Charter is sometimes cited to protect the dates and continuity of a fair, but originally the Charters served to protect and facilitate trade so that merchants could travel and trade freely not only across England but also from the continent. While the Charter carried the responsibilities for the conduct of the fair, it also ensured that the revenues it generated would flow into the coffers of the favoured.

The old fairs and markets complemented each other's function, the weekly market being the place of sale or exchange of local livestock and produce and the fair, perhaps held only once in the year, the forum for visiting merchants, drovers, and stock dealers. No stranger was allowed to trade within a town — in the Middle Ages, the Craft and Merchant Guild laws were extremely strict — except at the time of the Fair when the normal system of regulation was temporarily suspended and the Fair was regulated through the Piepowder Courts. These Courts (the name of which derives from the French *'pieds poudreux'* meaning dusty feet) had jurisdiction over tolls, trading disputes, debts, and other matters that had to be settled during the duration of the fair.

As a result of the depredations of the Black Death on the rural working population Edward III had introduced the Statute of Labourers. Intended to reduce the movement of scarce labour, it also created

a situation in which servants, men and women alike, could offer themselves for hire. The Statute Fairs, — 'Statties', Mops, or Hiring Fairs as they were also known — may seem to embody the quality of a lost rural idyll, picturesque events with carters wearing a piece of whipcord, thatchers a plait of woven straw, and shepherds carrying their crooks so that their skills would be plain for all to see. In reality they were a brutal labour market where employment was sought for the next year and deals struck. The Runaway Mop that followed a few weeks later gave a second chance to those who had not found hire and where those finding themselves dissatisfied with their original arrangements might seek a better situation.

The Fairs brought with them the wonder of the unfamiliar and the exotic both in merchandise and entertainment. Until the Victorian Age was well under way the major entertainments would have been the theatrical shows and the menageries or 'Beast Shows', supported by freak shows, waxworks, marionettes, acrobats, rope dancers, boxing contests, jugglers, fortune tellers, and games of skill. Not that all was innocent fun. The old fairs were rumbustious events providing for both business and holiday, and the weight of people gathered would have provided ample opportunities for the activities of pickpockets, prostitutes, and pressgangs. Perhaps the most famously scandalous was Bartholomew's Fair, originally a Cloth Fair, which after seven hundred years was finally brought to a close in 1855.

Fairs were rarely held on a strict calendar date; more often Fair Day was determined in relation to a particular date either from the secular or Church calendars. Even today showmen will know the dates of the old fairs both from a reading of the calendar and from knowledge of rules that are something of a mystery to most people. Thus King's Lynn Mart, traditionally the start of the season, begins on St

Valentine's Day but Pinner, established by a Charter of Edward III in 1336, falls on the Wednesday after Whitsuntide and Cambridge Midsummer Fair, granted by Charter of King John in 1211, still keeps to its June dates on its original site. Amersham's Charter is for the 19th and 20th of September but Horspath Feast is held on the Monday following the Sunday after September 12th. Oxford St Giles is held on the first Monday and Tuesday after the first Sunday in September providing that that Sunday is not the first of the month and just over a week later, on the second Thursday in the month, Neath Great Fair is held with a Charter dating from 1280. Bridgwater Fair is governed by St Matthew's Day, and Nottingham Goose Fair by the first Thursday in October. Princes Risborough's Charter, granted in 1523, is for the eve, the day, and the morrow of Fair Day, May 6th, while Woodstock, with a Charter from Henry VI, is the first Tuesday in October and the day before. And Newbury Michaelmas Fair falls on the Thursday after 11th October.

The Mop or Hiring fairs tended to be set at the end of the agricultural year, around Michaelmas, and the practice of hiring was still taking place at fairs up until and even after the First World War. Labour Exchanges were introduced in 1909, but it has been suggested that the passing of the 1924 Agricultural Wages Act was the most significant factor in the demise of the hirings. Although in any particular town such a fair may last only for a couple of days, from September onwards the Autumn fairs follow hard one upon the other and, for today's travelling showman who may open at several, the 'back end' becomes a very hectic time of the year.

The primary purpose of the old fairs was trade but, as the Victorian era progressed and the railways extended their reach across the country, distribution of goods of all kinds became easier and the old

trading customs changed for ever. The former stability of the rural population was affected as people left the countryside to seek work in the industrial cities and huge changes swept through the old Fairs in the last thirty years of the nineteenth century.

Steam, which had powered the factories and mills of the Industrial Revolution and brought about the communications of the railways, had touched agriculture also; steam engines were being employed for ploughing and threshing as agriculture became more mechanised. And steam power was soon to change the fairground almost beyond recognition.

Simple roundabouts are mentioned in accounts of 18th Century Fairs and the use of boys hired at the fair to push one such device is described by Lord George Sanger in his book *Seventy Years a Showman*. Other early roundabouts were propelled by harnessed ponies, but the 1870s saw the advent of the steam roundabout. Although not the inventor of the first steam-powered ride Frederick Savage, an agricultural engineer from King's Lynn, must receive full credit for the development of the centre truck on which was mounted a steam engine that could power the whole ride. Larger roundabouts could now be built and, perhaps more importantly, different types of centre-driven rides devised and developed which included the Sea-on-Land, Switchback, and the Razzle-Dazzle as well as the traditional Gallopers. Savage's works were located just off the Market Place where Kings Lynn Mart opens on Valentine's Day and in the late 19th Century the leading showmen of the day could see his latest rides in action while visiting the Mart.

As showmen vied to offer the latest and largest and most dramatic attractions their equipment, built up piece by piece and section by section off the ground, became larger, heavier, and more ornate. Many

trucks and horses would have been required to move the loads from place to place and some menagerists were transporting their shows across the country by rail. From the late 19th Century until the Second World War steam was increasingly to be the principle source of power for both transport and at the fair. The basic traction engine was itself to be transformed into a specialised variation, the Showman's Engine, highly decorated and fitted with a full length canopy traditionally supported on twisted brass pillars. Some were equipped with lifting cranes or winches, but soon almost all would carry a dynamo mounted on a bracket at the front of the smokebox and belt-driven from the flywheel. Electric light could now replace oil or naphtha lamps and, perhaps more importantly, with electricity on the fairground the stage was set for the development of a new generation of rides.

By the end of the Victorian era the fairground had been transformed almost beyond imagining. Although Hiring and Stock Fairs continued, the transition of the surviving trading fairs into Pleasure Fairs was soon complete. The new and thrilling rides were complementing the old shows and menageries, the freaks and illusions, the waxworks, the boxing booths and shooting galleries, the swing-boats and throwing games. Travelling photographers had long been on the scene, but in the late 1890s the bioscope arrived bringing moving pictures to the fairground. Eventually fairgoers would not only be able to see entertainment films of the day, but also footage especially made in their own locality in advance of the fair's arrival.

Standing on a fairground a century later amid the blare of pop music and looking up in awe at the latest high-tech computer-controlled hydraulically-driven rides, it is still hard to imagine the impact of those new fairground attractions at the beginning of the

20th Century. It is easy to forget how, especially in rural areas, the fair provided many with their first experiences of speed, of loud mechanically played music, of electric light and moving pictures as well as glimpses of the forbidden in peep shows and the exotic in the freak shows and menageries.

At the dawn of the Edwardian era a day at the fair would have been truly a day to remember.

The Showmen's Guild and World's Fair

The old fairs were gathering places for all kinds of travelling people, people whose way of life appeared very different from those of the communities to which they brought their wares and entertainments. The authorities tended to regard fairgrounds with suspicion, perhaps fearing disorderly conduct among such large gatherings of people in volatile and holiday mood. In 1882 the Bishop of Salisbury appointed an itinerant missioner to minister to the spiritual needs of the travellers who attended fairs throughout Wiltshire and Dorset, and this work continued into the period of the First World War. J H Swinstead, incumbent missioner from 1892-1895 recorded: *"An unknown people dwell among us in the form of van-dwellers and hawkers; where they come from or go to we have been at little pains to find out. The result is two-fold: we condemn them unknown, and they are shy of us because we are so unapproachable."*

Yet, while there were those who were determined to reach out to and to see the best in the travelling community, others set themselves against the migratory way of life. In the late 1880s one George Smith from Coalville was very active in promoting Bills relating to people whose business was of a migratory nature. Tarring all travellers with the same brush, he considered them no better than *"the*

dregs of society, that will one day put a stop to the work of civilisation, and bring to an end the advance in arts, science, law and commerce that have been making such rapid strides in the country." He zealously promoted the proposed 'Movable Dwellings Bill for Sanitation and Education of Van Dwellers'. Its proposals would have required the registration of all moveable dwellings, the compulsory school attendance of all van dwellers' children, and the introduction of a series of regulations concerning the number of people permitted in a given living space. In addition it would have granted local councils the authority for an officer of the law to enter a van with a warrant in order to inspect the dwelling for sanitation, health, and moral irregularities. Had it been enacted into law it would have led to draconian measures against all travelling people throughout the country.

Showmen would have been drastically affected, for not only did their business require them to move from place to place but with the transition of the old trading fairs into Pleasure Fairs many were making substantial and increasing investments in equipment. In 1889, a group of prominent showmen met at the Black Lion Hotel in Salford. As a result of that meeting, the United Kingdom Showmen and Van Dwellers Association was formed to oppose the proposed legislation. The opposition proved successful and the proposed Bill was defeated; but the Association remained in being. Notwithstanding the defeat of George Smith's proposed Bills, van dwellers and itinerants of all kinds were still regarded with suspicion in some quarters. In 1898 the Chief Constabulary Officer of Sussex Police gave instructions that in each division under his control a record be kept of travellers camping on each officer's beat and, due to the catch-all nature of the records which were maintained until the First World War, showmen too were recorded.

During the period of Lord George Sanger's Presidency the Association was reconstituted as a trade protection association for showmen and the subtitle 'The Showmen's Guild' had been added to the organisation's name. The Association soon began to influence the conduct of fairs, and in 1911 the old title was omitted from the Association's Year Book. In the same year the Showmen's Guild first lodged petitions in Parliament in its own right. Patrick Collins, one of the most important showmen of the day, succeeded Sanger as President. He was a member of Walsall Borough Council, serving as Alderman and Mayor, and in 1922 was elected as the town's MP. During the two decades of his presidency the Guild was translated into a national body. Its ten sections came to cover the whole of the United Kingdom and its influence on the interests of members spread both on and off the fairground. From the 1920s The Guild moved to further protect the rights of showmen by introducing restricted membership and the 'No Guild, No Ground' rule, as well as rules which would ensure the continuity of members' rights at fairs. This latter was particularly important: after all getting a living depended then as now on being able to open for business, and before a system of security of tenure was introduced there was great rivalry at the old fairs for the best positions and it was frequently a case of every man for himself. Without assured positions, investment in equipment might not have been an attractive proposition.

Today the Guild not only represents 95% of showmen at both national and local levels but also operates a code of conduct within the fairground community. More than 98% of fairs in Britain are run under the auspices of the Guild, and for many fairs the Guild acts as lessee. For more than a century the Showmen's Guild has effectively carried on the mandate set by the founders to separate travelling

showmen from other travellers and to defend the traditional occupation and way of life of the showmen of Great Britain. Although much of the day-to-day business of the Guild is concerned with the conduct of fairs, perhaps the majority of its work is in the unseen representations of members' interests in respect of proposed legislation. Even if today legislative proposals are not directed to disadvantage showmen as George Smith's Bill was, this does not mean that some of those proposals would not have serious implications for the industry.

Showmen are not only served by their own representative body, The Showmen's Guild, but also benefit from what is in effect their own weekly newspaper, *World's Fair,* which describes itself as *"dedicated to the world of fairgrounds, circuses, the steam preservation and the preserved transport movements".* It was founded in 1904 by de Francis (Frank) Mellor whose family business, The Owl Lamp Works, made lamps and water cans used by showmen of the time. On his visits to fairgrounds taking orders Frank Mellor found himself asked to carry messages from fair to fair. Sensing a need he started the *World's Fair* which, though not the first or oldest showmen's newspaper, has proved to be the longest surviving paper dedicated to their interests in the UK. The first copies were typeset by hand and printed on a single page, and it was not known whether the paper would survive beyond the first issue. But survive it did and it has become the showmen's trade paper. Most of the major fairs are reported in some detail, and the Classified Advertisements include equipment for sale, grounds to let, and notices of Guild business as well as personal notices of births, marriages, and deaths. It also keeps the showmen up to date with those aspects of legislation that affect their industry, and there are frequent articles of historical interest and

regular sections devoted to the circus and to the steam preservation and preserved transport movement.

From Fair to Fair

"If you think about it, when we go away we have with us the three most important things a man can have, his family, his home and his means of getting a living, they're with us all the time."

A funfair seems to be such a cohesive environment that its arrival or departure is spoken of as if 'the Fair' is an entity that moves from place to place as a whole, but in reality almost every fair is a unique combination of showmen who come together with their families and their equipment for each event. The 4500 or so showmen's families in the UK have been referred to as the largest dispersed village in the country, a village of which the family is the bedrock.

Most show families have roots within the business that can be documented back at least as far as the late 19th Century when the pleasure fairs began to supersede the old trading fairs, and many can be traced before then. During the 19th Century the way in which public records were kept changed. Civil registration of Births, Marriages, and Deaths as an adjunct to long established parish records was introduced in 1837. Although the first general Census was carried out in 1801, the earliest full Census records available are from 1841. It is very hard to search the early microfilm records for travellers who had no permanent address because census enumerators record the population street by street. However, the 1881 census has been transcribed and can be accessed relatively easily — it can be searched by name, occupation or even by keywords like caravan, tent, or circus. Besides the occupation

'showman' or 'travelling showman', it also includes descriptions such as shooting gallery proprietor, rifle saloon proprietor, menagerie proprietor, waxworks show, midget exhibition, steam roundabout or steam circus proprietor, traveller with swing boats, proprietor of marionettes, travelling conjuror, juggler, photographer, musician, confectioner — as well as the catchall description hawker. And among the names will often be found those of families still involved in the business today.

When home birth was the norm the travelling showmen's children were born on the fair. Because the census lists each individual's place of birth it is possible to gain some insight into the extent of a showman's travels over a hundred years ago. One family recorded in 1881 as originating in London had children born in London, Cornwall, Scotland, Lancashire, Norfolk, and Oxfordshire — a considerable range when living vans and equipment would all have been horse drawn.

During the travelling season a showman has with him his family, his home, and his means of earning a living. There is no separation between domestic life and work, and there is perhaps no other occupation in which the way the business is going — its difficulties, setbacks, and successes — is so clear to all members of the family.

Even if the showman's children are no longer actually born on the fair, their first view of the life is often from the counter-level height of a Silver Cross pram set beside the hoopla or other equipment which their mother or father is minding. Right from the start babies are absorbing the daily and weekly rhythms of the fairground. Later, as showmen's children begin to run around, they are never far from someone who knows them and will keep an eye out for their safety even at the busiest fair. From an early age they are

involved as the family moves from one place to the next, builds up equipment, opens, pulls down, and moves on. The youngster growing up on the fair is expected to help and gradually learns the business from parents and grandparents, not only acquiring a wide range of practical skills but also developing considerable self-reliance and learning the routines and necessities of hard work.

In conversation one showman casually remarked: *"You're the driver, the electrician, the mechanic. You fetch the water, you empty the chemical toilet. You've got to be a welder and a painter, a bit of a carpenter. You set the trailers, get built up, deal with the banking and the paperwork, check out the next place, sort out insurance, pay your rents. You have to know engines, and hydraulics – a bit of everything really because if you have a problem you just have to get on and get over it."*

However, while the practical and physical nature of the business remains, the industry does face increasingly complex regulations and the attendant paperwork. Dealing with insurance, terms of tenancies, banking, tax returns, applications for ground, even the driving test, all place growing demands on skills a sound education can provide. But keeping up with a formal education presents a particular challenge to families on the move. Many parents with children of school age speak of being sent to different schools wherever their family was open for business, and most are unequivocal in declaring that this arrangement did not serve them well. Some families who remain within relatively easy reach of their local school arrange daily transport to and from the school during the travelling season, although the demands of this arrangement do not always fit in easily with the fair's opening hours. In some areas the County Council's Traveller Education Service supports the child's winter school with a teacher visiting the fairground to support and

supervise the child as he or she follows work set in a distance learning pack. No matter how the problem is solved, parents with children of school age recognise the changing nature of the business and want to see the next generation equipped to face the demands of the future. It is perhaps appropriate to mention that a number of prominent showmen have websites to promote their business, and within the fraternity an increasing number of families have computers.

For most showmen the family base is a trailer or living wagon, which in many cases is home throughout the year. Today's trailers vary in size and luxury, typically incorporating a fitted kitchen, bathroom, bedrooms, living room, tanks for water and for waste. Pullout sections extend the living space beyond the width permitted on the road, and oil or gas heating has superseded the once popular solid fuel Hostess stove. As they grow older children may have their own trailer – the 'own bedroom' equivalent as it were of their house-dwelling counterparts – and are said to be 'still living at home' until they are married. From the perspective of a modern fully appointed trailer it is hard to imagine how a hundred years ago families with several children managed in the 12 or 14 foot horse drawn wagons sometimes seen in old fairground photographs.

It is often said that it is extremely difficult for an outsider to learn a way of life which if not inborn is absorbed virtually from birth. Although people do 'marry in', the majority of marriages are within the business and such marriages further strengthen the community. It is highly likely that when a couple marry they will have known each other for a long time if not for most of their lives. There was a time when it was somewhat unusual for a person to marry outside their own Guild Section or the family's travelling area. An astonishing web of inter-relationship links the families across the country as a

natural consequence of the tendency of marrying within the business and, in such a close-knit community, the reputation and good name of the family is always open to scrutiny.

Unlike those many weddings at which the couple's families may be strangers to each other and friends and relatives have never met before, at a showman's wedding there is a strong sense of coming together of relations and old friends. As one showman said to me after the first wedding I attended, *"There must have been several hundred people there that night and I could say I knew them all."*

During the travelling season everything revolves round the hours the fair is open. Although some supplies like fuel for generators, swag, lamps, price tickets, and gas may be delivered to the fairground there are always jobs to be done. Equipment needs regular maintenance or unexpected repair, and the normal routines of family life — the shopping, washing, and ironing — have to be fitted into the hours between opening or moving from one ground to the next. When the weather is bad and business drops off, the home still has to be kept clean even when the family comes in cold, wet, and dispirited from a muddy field and, because presentation is so important, equipment will need extra washing down. Depending on the amount of equipment involved as well as the number of drivers in the family, moving from place to place presents its own logistical challenge often requiring more than one journey — to move only a few miles could possibly take all day.

Each family has its own run of fairs and while some showmen only rarely cross a county boundary, others criss-cross the country catching major fairs. Sometimes several families will be in each other's company for weeks at a time, perhaps as tenants of the same lessee at successive places, while other

families' paths may cross only once or twice in a season. Fairs are key points of reference. Sometimes a showman will better explain when a particular fair is to be held by counting forward weekend by weekend and place by place from the time of enquiry, and often if asked when a particular event occurred the response will include *"It was when we were open at…"* as a marker.

Holding rights to ground at major fairs is not only one of the showman's key assets, but also one that can be valued according to the prosperity of the fair. Ground has a value and within the Guild Rules can be bought sold or sublet to another showman as well as handed down within the family. Acquiring ground allows the business to expand as children reach the age when they can mind a ride or stall. However the showman is almost always operating on land controlled by others, and if use of a site is irretrievably lost due to reasons beyond a showman's control — such as redevelopment — the assets of his business are affected. Even the installation of new signs or changes to the layout of kerbs in a street where a fair is held can severely affect a showman's ability to operate there.

Not all fairs are organised in the same way. Some are run by Local Authorities, some by the Showmen's Guild, and many more are organised by individual showmen. Sometimes a fair opens in conjunction with a carnival or other festival and sometimes organisers of private events contract a showman to provide rides to supplement other attractions.

The organiser of the fair (the lessee) rents the site from its owner and collects rent from other showmen who open at the fair as his tenants. In many cases the lessee will advertise in *World's Fair* so that other showmen wishing to be tenants at the fair can apply for ground. Even at the major fairs, where showmen have established rights, applications are still submitted each year. This ensures that the lessee has control over the variety of the attractions that make up the fair. The lessee's other responsibilities include setting out the ground and ensuring that local byelaws or other regulations are complied with, that regulations relating to safety are met, and that the site is left tidy and in good condition. This latter can be a particular cause of concern when the fair is held in a park softened by rain, and in some cases the owner will require a bond to cover the costs of reinstatement if damage is caused.

Enterprises on the fairground come in a huge variety of sizes and styles. Some showmen run small family concerns with no more equipment than the family can itself manage; others manage large businesses, with a range of equipment operated not only by family but by managers as well. A young couple starting out may be getting a living with one or two round stalls while another family are open near them with two or three machines. Some showmen confine themselves to a local run of fairs whilst others travel far afield. Some may open as tenants at some fairs but be lessees at others; and still others travel their equipment abroad. And the impressive fair held in the Mall in central London to mark the Millennium celebrations was organised by a consortium of prominent showmen.

Safety on the fairground is always a paramount consideration. No matter how stomach-churning the latest rides may appear to the spectator, the safety of the rider is always paramount. All new equipment has to satisfy a stringent set of safety regulations, and showmen cannot operate any equipment without proof of recent independent inspections and valid public liability insurance. Showmen in fact know their equipment inside out and are very safety conscious, and many argue that the repeated building up and pulling down of travelling equipment provides excellent opportunity for additional routine inspections. Serious accidents are extremely rare, but in the event of one occurring media headlines do not usually distinguish between static rides on theme parks and attractions on travelling fairs, and the news travels like a shockwave through the community in which the owner of the equipment — perhaps even the ride itself — will be widely known. *"How do they think we feel,"* a showman remarked to me, *"when we let our own kids go on the rides?"*

As in all business, showmen rely on the goodwill of their customers. As someone said to me at a summer fair *"If I'd done half the things people say we do, we'd never be allowed back, yet we're here year after year."*

Traditionally the travelling season would have been from about Easter until the last of the mop fairs in October or early November. During the winter showmen exchange the temporary and changing community of the fairground for more settled neighbours in their winter quarters. These winter quarters or yards, of which there are many across the country, are not temporary encampments but owned and permanent sites. Some are home to one extended family, others are large enough for the owner to let winter pitches to other showmen, and at other sites a number of separated yards are laid out within the same perimeter.

Even today showmen are frequently greeted with suspicion because they live in trailers and their business requires them to travel from place to place. Many people fail to recognise that showmen are a separate cultural group from other travellers and, in the face of confusion and misunderstanding about their way of life, finding new sites and obtaining planning consent for use as winter quarters is often problematic.

Yet a yard is an essential. It not only provides a winter base for the family from which children can attend local schools, it also provides a workspace where lorries, generators, and other equipment can be maintained or improved or even built from scratch. In the travelling season the showman's lorry serves as a workshop base for odd repairs. In winter small jobs might be done in the back of the same lorry or in a shed. Often a workspace created under a sheet stretched between two vehicles accommodates and shelters the work in progress but, because of the size of most rides and shows, a great deal of work is of necessity done in the open where the showman is once more at the mercy of the weather.

After pulling in for the winter many families have traditionally taken to other work. A showman with particular skills may work for others within the fraternity – perhaps painting or building or modifying equipment – while others take advantage of skills developed in the business to take on temporary employment. Meanwhile for some the season extends towards Christmas as they attend 'the switching on of the lights' events in town centres. And there are yet others who travel their equipment abroad: some have opened in China, Singapore, Oman, Dubai, Iceland, Russia, Morocco, as well as in Zimbabwe, South Africa, Botswana and Mozambique.

The Thame Fairs

But my involvement began locally, so what of Thame's two fairs, Thame Show Fair and the older Charter Fair, which are held in the centre of the town in the early autumn?

Thame Show Fair – which is organisationally entirely separate from Thame Show – commences on Show Day, the third Thursday of September. The precise historical origins of the Show Fair are not clear although, in what is widely regarded as the most complete and accurate list of fairs published in the last century, Margaret Baker writes that the Fair held at the time of Thame Show *"may be a survival of two fairs granted to Thame in Norman times."*

The origins of the Show itself are better documented. In October 1855 a ploughing match held near Thame was followed by a public dinner at the Spread Eagle Hotel when it was suggested that the match become an annual event. There was already a Horticultural Society which in the same year had held its eighth fruit and vegetable show. When these events were combined with additional agricultural classes the organisation became known as The Thame Agricultural and Horticultural Society, and the first official show of The Thame Agricultural Association was held in 1888 at The Moats in Wellington Street.

Whether or not the Show Fair is in fact a survival of an earlier fair may or may not be established, but we can be sure that the opportunities for providing entertainment where people gathered in holiday mood would not have escaped the attention of the travelling showmen of the day. And by coincidence the Show was becoming established at about the time steam driven rides were appearing on the fairgrounds.

The second fair, the smaller Charter Fair, is held three weeks later in October.

The Charter, Michaelmas, or October Fair —'Second Thame' or 'Little Thame' as it is sometimes referred to by the Showmen — is a survival from the granting of a Royal Charter in 1215 in which King John *"in recompense also of robberies, injuries and damages done to the Church of the Blessed Mary of Lincoln, and to the Venerable Father Hugh, Bishop of Lincoln the Second, in the time of the general interdict,"* gave granted and confirmed ...*"that the aforesaid Bishop and his successors shall have Fairs every year to endure three or four days, and Markets every week for one day, throughout all their manors, when and where they shall please and be able to have them without injury of neighbouring fairs and markets appertaining."*

With the establishment of these rights came the diversion of the old Oxford to Aylesbury road through the centre of the town to create an easier access to the markets and the fairs. *"A Genuine and Authentic Account of all the fairs in England and Wales"* was compiled by William Owen and published by the King's authority of 1762. His list includes Thame old Michaelmas October 10th *"for hiring servants horses and fat hogs"*, and also Thame Easter Tuesday *"for all sorts of cattle"*. The Easter Tuesday Fair, however, does not appear in the List of Fairs included in the report of the Royal Commission on Market Rights and Tolls of 1888 and is no longer held. George Rawlins, who has opened at the Thame fairs all his life, recounted memories of horses being sold at the Charter Fair before the second World War, and Harry Godfrey writing in *World's Fair* in 1957 referred to the passing of the old customs of hiring and horse-dealing and noted that a well known Bicester dealer had brought the last horses to the fair some nine years previously.

Although this fair is now held on the Friday and Saturday nearest October 11th, early in the 20th century the old Michaelmas date was still kept. The *Thame Gazette* for October 6th 1908 records that a letter was read to the council concerning the October Fair. In that year the Fair was to fall on a Monday, and W J Arnold the Toll Collector wrote *"to ask your Council to*

give permission for the various showmen's vans etc. to enter the town on Sunday Oct 11th next after 4pm so that the majority may get placed that evening... I shall be pleased to hear the request meets your approval as it would then help my duties, often unpleasant if late in the day."

It is noted that after some debate the council agreed to the request! Mr Arnold was writing in his capacity as representative of the Lord of the Manor, Viscount Bertie of Thame, who then owned the Market Rights.

At that time those wishing to open at either fair would have negotiated with Mr Arnold for their pitches and their rents would have been paid to the Lord of the Manor. Thame Council Minutes record that in 1925 Lord Bertie unexpectedly visited Thame and stated his willingness to sell the Market Rights to the Council. There was however a rider – if not taken up at his price the Rights would be put up to auction but, if a transfer could be agreed on his terms, he would offer no objection to the council's acquisition of land in East Street for housing. Negotiations were somewhat protracted but transfer of the Rights was finally concluded and in September 1927 Mr W J Arnold accepted the position of Market Super-intendent and Tolls Collector with the council, a position he was to hold for many years. Rents for the Fair (and Market) now passed to the Town Council rather than to the Lord of the Manor.

The fairs continued until the outbreak of War in September 1939 when Harry Godfrey recorded that *"England's biggest and best one-day show, Thame, Oxfordshire, has, like many other agricultural shows, been cancelled and with it goes the colossal street fair which is always associated with this event."* Many showmen were to serve in the armed forces just as an earlier generation had served in the Great War, and in 1940 the Showmen's Guild appealed to its

members to raise the funds required to purchase a Spitfire (later aptly named *The Fun of the Fair*) as a contribution to the war effort. During the war years funfairs operating under blackout conditions remained an important part of available leisure activities as the government implemented its 'Holidays at Home' initiative.

Although the traditional fairs did not resume at Thame until 1946, showmen did open there during the war. In September 1942 Harry Godfrey, writing in *World's Fair*, records in his Oxfordshire Notes that *"Mr John Studt was paying his first visit with machines to Thame."* This fair was held on the Recreation Ground, *"where I found quite a crowd of punters enjoying the fair. The lessee had two machines here, the motor cycle speedway and the dodgems. Both the rides although on the small side looked smart and were riding very well. The music was provided by a panatrope playing a fine collection from classical to the present day stuff. Supporting the rides were four wheel'em ins; a juvenile roundabout; Madam Rosenar, palmistry; park swings, an emma representing Hitler and his gang; jungle shooter and a Wembley shooter by the usual followers. It was quite a nice little gaff, and in my opinion quite large enough for private business."* The term private business refers to the arrangement where a showman rents a site from an owner, acts as lessee and sublets to tenants, and the emma would have been a throwing game capitalising on the spirit of the times by offering images of the German High Command as targets.

In mid January 1944 Harry Godfrey reported that *"Mr William Wilson's blackout winter fair (which had been opened on December 2) still continues to draw a fairly big crowd of pleasure seekers every weekend."* A funfair without bright lights is almost a contradiction in terms and sheets would have been stretched between

stalls and other equipment so that the operation would comply with blackout restrictions. Later that year Fred Ward of Gravesend was the lessee and the attractions included his super dodgems, electric gallopers, and the flying chair-o-planes and the fair was open for three weeks and *"during the evenings of Wednesday, July 19, and Saturday, July 29, a percentage of the takings were given to the Victoria Hospital and the Welcome Home Fund respectively."*

When the usual fairs resumed in 1946 Harry Godfrey wrote of the Show fair that *"because of the steady downpour of rain ... the showmen who had brought the largest fair ever seen in Thame suffered a considerable financial loss"*. It was hardly an encouraging resumption of business and within three weeks he was reporting that the Charter fair was *"the biggest October fair ever seen (at Thame) and one of the worst from a business point of view."*

Until the 1960s, the general organisation of the fairs remained as it had been before the war with the incumbent Market Superintendent (the Tollman) collecting rents from individual showmen.

However in 1963 Thame Town Council sought a different arrangement so that the negotiation between the council and the showmen be simplified and in that year the Showmen's Guild became lessee of the fairs for the first time. However this did not immediately become a permanent arrangement; the Guild took the fairs until 1967 but in 1968 Tom (Gus) Smith's tender was accepted. In the following year George Webb was lessee and in 1970 George Pettigrove took the fairs.

But in 1971 the Showmen's Guild was once again the lessee and this is the arrangement that continues to this day.

Thame – The fair arrives

"We look forward to going to the streets — Abingdon, St. Giles, Thame Show. You see some of your friends that you didn't see since last year whether it's showmen or general public." Joe Rose

For several years now I have arrived in Thame early on the Wednesday when the Show fair arrives. Barriers close off the street and traffic is diverted away from the centre of the town. Until Sunday morning an alternative reality will take over the street, the familiar will be transformed, routines interrupted or suspended. Already two or three trailer mounted rides, brought through after the pull-down at Witney Feast, are set ready for building up. The signposts have already been removed from the car park and with the area unusually empty, it's easier to see the paint marks that set out the ground. Hanging baskets have been taken down and bollards have been removed from the traffic islands.

Three routes lead into the town and when the pull-on begins the showmen arrive more or less in the order in which they build in the street. The big rides and arcades come in first, followed later in the morning by the smaller stuff. Loads and lorries are inched onto packing, axles taken out from under arcade trucks. Beyond the Town Hall the centre of Mrs Sandra Pettigrove's Tidman Gallopers has been set and the top is almost built up. Teenagers on their way to school compare expectations and memories of the fair.

I am there meeting people, talking, photographing. *"Still taking pictures then?"* somebody asks. I am not among strangers. As soon as Tony Spurrett has levelled his lorry and the shooting gallery, I leave my spare cameras, a coat – anything I don't actually need in my hands – with him for safekeeping.

Back at the other end of the fair John Brixton has uncoupled and positioned the Meteorite, the ride I first experienced nearly twenty years ago and which I photographed when it was stripped and dismantled for a major overhaul in the yard one winter.

I watch the Tristar being built up, always in the same spot to the inch, and remember photographs when the fascia of the shop behind it read *The Golden Cod*, another year *Kebab House*, now *Sammi's BBQ & Pizza Take-Away*. Two shifting landscapes play one against

Guild Stewards, Henry Farr, Lou Placito and David Traylen Thame Show Fair 1996.

the other in an annual encounter. Images from the years I have been watching the fair's arrival come to mind accompanied by snatches of stories, snatches of history.

I think of Betty Dunklin recalling how Uncle Rinkie Shaw used to patronise Mr Millward the outfitter's shop, premises that are now occupied by the Oxfam Book Shop. A little further along a bank has become

a betting shop. George Wilson builds his Space Train ride on the corner of North Street. His grandfather Pickard's Boadicea Spinner used to stand there; when he died in 1944 the cortege stopped at the corner near the Market House and the coffin was set on the family's ground for a period of respect before proceeding to Rosehill Cemetery in Oxford for the burial. George's ride will operate under the sign to Haddenham and Thame Parkway, the nearest access to rail services since Thame's own station fell to Dr Beeching's axe in 1962 together with the line through to Oxford. I have not yet discovered whether a Bioscope ever opened at either of the Thame fairs before the First World War but the cinema arrived in 1914 and The Grand, the cinema in North Street to which Joe Rose told me he never went, closed in 1967. And All Saints Church, the corrugated metal church where Tommy and Daisy Wilson had their children christened and which had stood for a hundred years, was demolished in September 1985.

Meanwhile, up and down the street, generators rumble, powering up the winches and hydraulics that open the arcades or unfold the major rides. Morning shoppers pick their way amid the unusual activity of a workplace apparently governed only by tape measure and spirit level. Packing tossed from belly boxes slaps down onto tarmac; by the old market house a network of steel spreads to support the plates of the dodgem track. It's heavy but familiar work. Guild Stewards are on hand to help resolve any difficulties that may arise.

Specialist suppliers visit the showmen in the street, bringing diesel for the generators, replacement lamps, bottled gas, tickets, and signs. The swagman delivers prizes to the stallholders and there are piles of huge polythene-wrapped soft toys between the joints and hooplas. Up at the field where the trailers are parked the teacher is working one to one with

some of the children. There's a pause in the work for a cup of coffee and a sandwich or pasty, something hot and quick. Over the years many showmen patronised Wright's bakery, but as the fair opened in 2002 news came that that shop would shortly be closing down. In a strange twist, the street seems suddenly to be transitory and the fair constant. Indeed when a scheme to revise the layout of paving, street furniture, and car parking in front of the Town Hall was implemented in the winter of 1996/97, two residents were overheard agreeing that it was not only a waste of money but that it was *only being done to stop the fair!"* In fact there were proposals to alter the layout of the 1997 Show Fair but the Showmen's Guild made successful representations in which they were backed by a petition raised by local resident and fair supporter Frank Messenger, who in a mere four hours collected over 1200 signatures in support of maintaining the existing layout.

To many the showmen remain an unknown people and the fair an unwelcome disruption. Yet the continuity of attendance of some of the show families is extraordinary. I recall Lena Biddle rather wistfully telling me how she had seen the mature tree opposite her ground grow from a sapling planted when the Car Park was separated from the thoroughfare many years before. She had attended Thame Show Fair all her married life, and was still there with her daughter minding her coconut sheet in 1998 at the age of 88. In 1972 the Hatwell brothers, whose Royal African Shooter had then attended the Fair for almost 80 years, had on show one of the guns used at Thame Show Fair in 1894. In his 1969 report for *World's Fair* Peter Barnes noted that *"the honour of being the oldest tenant at the Fair was shared by Mrs A Buckland and Mrs G Harvey Snr., Mrs Buckland, who is 78 years of age has been attending Thame Show Fair for 56 years. Mrs Harvey has not been coming for quite so long, but is looking forward to*

Opening of Thame Show Fair 2002. Bill Pettigrove and his daughter Louise; John Crick; Councillor Mike Welply, Mayor of Thame; Nathan Buckland; John Nichols, Sergeant at Arms of the Showmen's Guild; Henry Farr; Councillor Beatrice Dobie; Lou Placito; Rosie Gray and Violet Rawlins.

celebrating her 89th birthday." It strikes me as an irony that in a town like Thame, which has expanded so much with both light industry and with housing in the last forty years and where a large proportion of the local population are relative newcomers, the showmen on their annual visit will have family connections with the town going back further than those of most residents.

In 2002, for the first time in its history, the Show Fair was officially opened by the Mayor of Thame, Mike Welply, who expressed a warm welcome to the showmen and his unequivocal support for the fair. Among those assembled on the step of Harry Hebborn's Waltzer were officials of the Showmen's Guild and representatives of some of the families with a long association with the fair.

The most easily accessible — if not the only — written public record of which showmen have attended the fairs over the years are the reports in *World's Fair*. At about the same time as control of the

fairs passed from the Lord of the Manor to Thame Town Council, Harry Godfrey began writing for that paper and Peter Barnes, who first visited Thame Show Fair as correspondent for *World's Fair* in 1966, succeeded him. Their accounts provide a perspective on the changing attractions on the fairground and a glimpse of the continuity of the families within the business. In 1929 the major rides mentioned were typical of the well established favourites at fairs of the day: Charles Thurston's Scenic Dragons, John Flanagan's Gallopers and Chairoplanes, Thomas Pettigrove's Gallopers, Charles Abbott's Cakewalk, Arthur Traylen's Helter Skelter. There were shows too: Shufflebotham's Wild West Show, Purchase's Lion Show, and Alf Stewart's Boxing Show. And of course there were traditional smaller attractions, hooplas, and sweet stalls. Coconut sheets were provided by the Bucklands, and George Hatwell presented the family's Royal African Shooter. In 1931 Jacob Studt was there with his Noah's Ark and Dodgems, the old and the new together, for while the

Peter Barnes
Thame Charter Fair 1995

Ark was by then an established attraction the Dodgems were a relative newcomer as was The Wall of Death presented by W Desnos. And in 1933, Charles Thurston presented his new thrill ride, The Waltzer.

Today some seventy years later, when the Gallopers are being built up, the horses are still carried on the shoulder as they were then — indeed as they have been since the first steam sets appeared in the late 1800s. Today's Dodgems are still drawing power from an electrified ceiling mesh, the 1920s innovation that made free movement of the cars possible at a time when most rides were centre-driven. Donald Ive's Night Rider Waltzer is built up just as Charles Thurston's would have been, off the ground on packing, with the platforms secured one to another by long rods driven in to serve as both anchor and hinge. And of course the hooplas and coconut sheets have changed little over the years.

Every year something of the familiar and time-honoured remains. But the lifeblood of the fairground is change, and at the fair the traditional and the innovative stand side by side. Novelty has always been the key to attracting the public's custom, and of necessity showmen have always been attuned to the tastes and preoccupations of the fairgoers, modifying attractions or creating new ones. At the time of the Boer War ostriches and military figures joined the traditional horses on the Gallopers, and the then new-fangled motor-cars were first added to rides in 1904. During World War II some showmen replaced the toys on kiddies' roundabouts with military–style vehicles, while in 1967 at the Show fair *"Another sign of the times was to be found in the prizes offered at several of the stalls. Nathan Buckland had a printed sign offering prizes of Hippie Flower Bells on his bagatelle stall, and similar prizes were offered on Tommy Stanley's roll-down hoopla."* More recently some stalls have offered Spice Girl posters and Tamagochi cyber pets as prizes.

Every year new attractions are presented which not only offer variety over previous years but also push forward with innovation. And, as tastes and times change, some once-favourite crowd pullers disappear. Although I read that in the mid 1950s Harry Saunders presented *Sealetta, Part Seal, Part Woman* and fairgoers could see Henry Summers' *Slave Girl and her Reptiles*, such novelty shows have given way to fun houses and mirror mazes.

In 1967 Peter Barnes reported in *World's Fair* that at Thame *"the one big show was Jack Gage's Boxing Stadium"* which had also been mentioned in the 1933 report. The fairground boxing booth had its origins in the old bare-knuckle contests, and Thame has something of a claim to fame for James Figg, a famous prizefighter who died in 1734, was a native of the town. After the introduction of the Marquess

of Queensberry rules boxing booths became an increasingly popular attraction on the fairground and many famous boxers developed their skills on the fair, Freddie Mills and Randolph Turpin among them. However for a variety of reasons these shows gradually died out and, when Ron Taylor closed his boxing show for the last time at Nottingham Goose Fair in 2000, a whole chapter of fairground history closed with it.

Shooting galleries too were once fairground favourites and there are many references to them in the 1881 census. Jimmy Hatwell, whose family used to come to the Show Fair with their Royal African Shooting Gallery, tells a family story of how John Fothergill, the eccentric owner of the Spread Eagle, *"used to bet his friends he could shoot better than them knowing that the lady proprietress (namely my grandmother) would make sure he had the gun with the best sights so that he would always win..."* As late as the 1970s there were three live ammunition shooting galleries at Thame Show Fair. Now all but one have disappeared — Tony Spurrett's, where my involvement with showmen began.

Watching the latest high-tech rides being built up I reflect that over the years every generation of rides has been well represented at the Thame fairs. The Scenics, the Swirl, the Skid, the Italian Bif, the Tunnel of Love, the Speedway — all these have come and gone. Rides which basically operate in the horizontal plane have been joined over the years by aerial rides like the Chairoplanes, Big Wheel, Jets, Octopus, Rock-o-Plane, Dive Bomber and Skyliner. And again from the reports it is possible to gain an idea of the changing technology that has made possible rides like the Paratrooper, Meteorite, Orbiter, Superbowl, Enterprise, and Stargate. Steam power changed the face of fairground in the late the 19th century only to be superseded in turn by electric

drive and a new generation of rides, and in time hydraulics would be applied in all manner of ways to the showman's equipment. Hydraulic rams are now used to level and unfold arcades, hydraulic drive units power the latest generation of rides, and hydraulic rams enable the centre to be lifted allowing a departure from the horizontal plane of rotation employed in those rides that were the immediate successors to the roundabout.

In every way the fairground can be said to be rooted in tradition but not living in the past. If the Gallopers are a lasting reminder of the birth of the modern pleasure fair in late Victorian times, then the arrival of Bob Wilson Fun Fairs' impressive new 'Booster' Bomber from the Italian manufacturer Far Fabbri just in time for the 2001 Show fair must symbolise an extreme in modern travelling thriller rides. What would the fairgoers of a hundred years ago have made of this machine carrying its eight riders 140 feet into the night sky in two free-spinning open cars!

Fire Hydrant Testing
Thame Show Fair 2002

As the day before the fair wears on, the pace of activity in the street changes. Machines are washed down, glass in the mirror mazes cleaned, and refreshment kiosks prepared. Hooplas and side-stalls are built up. Insurance and test certificates are inspected. By late afternoon the juxtaposition of equipment and street is complete, and the showmen have returned to their trailers leaving behind a new landscape. Virtually the whole centre of the town is filled with showmen's equipment, and tomorrow when the fair opens there will be something for everyone. As dusk falls the street is silent but in the early evening there is a brief flurry of activity as two important safety precautions are observed. A St John's Ambulance post is set up near the middle of the fair and the fire engine is driven through the thoroughfare to check that emergency access is clear between equipment, and all the fire hydrants are checked to ensure that they are both working and free of obstruction.

Passing the Spread Eagle I recall reading how John Fothergill recounts in his diaries that in 1926 *"A young artist, a French Viscount from Wendover, sat upstairs and painted the night fair scene without."* Further along lies The Swan where in the late 1960s showmen with their families attended dances on the eve of the fair. And, although not held at Thame for some years, a tradition of showmen's dances at fair time continues at other fairs like Oxford St Giles, Nottingham, Newcastle and Hull, an opportunity to renew old friendships and make new ones as showmen from different areas of the country come together. Opposite the Dodgems stands Tommy Wilson's Rolla Ghosta which I had photographed in the yard while it was being redecorated by Mark Gill, and I remember asking Tommy if he would allow me to make his photograph at one of the Show fairs. Perhaps his willingness took me by surprise because as I raised my camera he gently reminded me that I

should remove the lens cap! I could not have known then that he and his family would make me so welcome at his daughter's wedding nor guessed that I would one day encounter him in fancy dress as a vicar. I reflect on the fancy dress parties and the pleasures of seeing through assumed identities, of going beneath the first impressions, and I set this against the certain knowledge of how judging by appearance is so misleading and damaging in every day encounters. As I leave the street I know I am both fortunate and privileged to have been allowed a glimpse beneath the appearances of the fairground and its people.

And, as the night before the fair passes, the only questions remaining are "Will the weather stay dry?" and "Will the crowds turn out?" And, most important of all, "Will they spend?"

John Comino-James, March 2003

Acknowledgements

I want to thank my wife Anna not only for her active support but also for her understanding and tolerance of my many hours away from home visiting fairs, yards, and showmen's social events.

Two friends, John Blakemore and Kim McCabe, have encouraged me while this body of photographs and my relationships within the fairground community have developed. Vanessa Toulmin, Research Director of the National Fairground Archive, has contributed a generous introduction; and both she and Michael Mellor, Editor of *World's Fair*, have made it possible for me to gain access to valuable historical material. From knowledge accumulated over many years the late Peter Barnes willingly provided me with more information than I could possibly use concerning Charters and the calendar rulings by which so many fair days are set, and Maurice Kirtland of The Thame Historical Society has helped with local detail.

And finally, of course, I must thank the showmen themselves. I am indebted not only to those who I have photographed at the Thame fairs and who have welcomed me into their yards and have made me feel so included in their family celebrations, but to many others who I have met and talked to at fairs up and down the country. For without the generosity of so many people these and many other photographs could not have been made, my interest in the history and community of showmen would not have grown as it has done, and this book could never have come to fruition.

John Comino-James

For further information

Showmen's Guild
The Showmen's Guild of Great Britain
Guild House
41 Clarence Street
Staines TW18 4SY

World's Fair
Michael Mellor
Editor
The World's Fair Limited
PO Box 57
Hollinwood Business Centre
Albert Street
Oldham OL8 3WF

National Fairground Archive
Dr Vanessa Toulmin
Research Director
National Fairground Archive
University of Sheffield Library
Western Bank
Sheffield S10 2TN